Color for designers

Color for Designers
Ninety-five things you need to know when choosing and using colors for layouts and illustrations

Jim Krause

New Riders
Find us on the Web at www.newriders.com
To report errors, please send a note to errata@peachpit.com

New Riders is an imprint of Peachpit, a division of Pearson Education.

Copyright © 2015 by Jim Krause

Acquisitions Editor: Nikki Echler McDonald
Production Editor: Tracey Croom
Proofreaders: Jan Seymour, Emily K. Wolman
Indexer: James Minkin
Cover Design and Illustrations: Jim Krause
Interior Design and Illustrations: Jim Krause

ISBN 13: 978-0-321-96814-2
ISBN 10: 0-321-96814-X

9 8 7 6 5 4 3 2 1

Printed and bound in the United States of America

Color for designers

Ninety-five things you need
to know when choosing and
using colors for layouts and illustrations

Jim Krause

TABLE OF CONTENTS

INTRODUCTION

Say you pull into a service station with an engine problem. And that it's your lucky day. A mechanic with an unmistakable air of mastery strides out of the garage, opens the hood of your car, listens briefly to the engine, asks you a couple questions about its behavior, nods knowingly, and gives a wink as if to say, *Not to worry, I'll have you on the road in a jiffy.* Clearly, the expert mechanic's intuition has already zeroed in on the one or two fixes that will almost certainly handle the issue.

Relief fills your mind, and also the questions, *What, exactly, fuels this expert mechanic's problem-solving, mystery-dissolving, and confusion-absolving intuition? And why can't I even begin to figure out a problem like this on my own?* This answer, of course, is simply that the skilled mechanic has an abundance of two things that most of us lack completely: knowledge and experience related to the inner-workings of automobile engines.

Engines and color, as it turns out, have something in common. Both seem mysterious, complicated, and often troublesome to those of us who have not yet learned how they operate. And while this book (as you probably suspect) won't help you one bit when it comes to dealing with under-the-hood automotive issues, it is specifically designed to do away with the sense of complication, intimidation, and befuddlement many artists feel when working with color—graphic designers, Web designers, illustrators, photographers, and fine artists included. And we're not just talking about beginner- or intermediate-level practitioners of the visual arts here: Many are the experienced art professionals who demonstrate great proficiency in nearly all aspects of their craft, but still claim only a tentative feeling of know-how when it comes to choosing colors for—and applying colors to—their creations.

6

In a nutshell, then, I created *Color for Designers* as a book that aims to replace mystery, intimidation, and befuddlement with knowledge, confidence, and the intuitive prowess necessary to accumulate the experience you'll need to achieve true creative poise and proficiency when working with color. And I should point out, right here, that competence with color requires a good grasp on only a few easily understood fundamentals—basic principles that can be applied far and wide to create aesthetically sophisticated, visually engaging, and communicatively effective palettes for layouts, illustrations, logos, and works of fine art. In fact, once you make it through the first three chapters of this book—chapters dealing with the three components of color (hue, saturation, and value), the crucial importance of value (the lightness or darkness of a color), and a handful of color-wheel– based palette-building strategies—you should be well equipped to understand the rest of the book's content and to begin applying what you've learned to projects of your own.

Color for Designers presents each of its 95 topics on spreads of their own. To me, this sets a nice, even pace for the flow of the book's information and ideas while also making it possible for readers to either sit down and studiously read the book from beginning to end, or to pick it up on a whim and thumb through stand-alone subjects presented on randomly selected spreads. (That said, readers who are relatively new to the subject of color may want to approach the book in the traditional beginning-to-end manner—at least the first time through—since material covered early on tends to be referred to and expanded upon as the book progresses.) If you want to give yourself a good idea of how this book's subject matter is organized and how broad its coverage is, the table of contents, on pages 4 and 5, does a good job summing things up.

Once you've had a chance to look through a few spreads of *Color for Designers,* you'll see that its content is generally presented as more or less equal

parts text and imagery. The text is as straightforward and easy to understand as I could make it (there's a glossary at the back of the book that you can refer to if you do come across unfamiliar terms). And, as with this book's Creative Core companion volume, *Visual Design,* the text strives to be pertinent and practical—though not without the occasional ironic or cheeky insert. As far as the images go, I hope you'll find these to be as informative, concept enforcing, and idea sparking as they are varied and enjoyable to look at. In any case, I thought it was important to include lots and lots of images to go along with the book's textual info since, after all, this is one book that's aimed squarely at a demographic of visual learners.

The illustrations in *Color for Designers*—as well as the digital documents for the book itself—were produced using the same three programs most designers, illustrators, and photographers use to create their own works of design and art: Adobe InDesign, Illustrator, and Photoshop. Few step-by-step instructions on how to use these programs are offered in this book, and the reason for this is simply that the specifics of how any particular version of a program performs its functions will likely change during what I hope will be the shelf life of *Color for Designers*—a book filled with color-related principles that began taking shape as soon as cavemen were able to find enough different berries to smash and stones to grind to fill a color wheel with hues. So, if you come across a software tool or treatment in *Color for Designers* that you'd like to try out on projects of your own, take a look—if necessary—at your program's Help menu and find out how things work (none of the digital tools and treatments mentioned in the pages ahead are overly complex, so learning them shouldn't be too much trouble).

Thank you, very much(!), for taking a look at *Color for Designers*. This is my fifteenth book on subjects dealing with design and creativity, and color is something I never get tired of exploring, experimenting with, applying to my own works of design and art, and writing about. I hope you enjoy this book, and that it goes a long way in clarifying and expanding your understanding of how colors can be selected and applied to both personal and professional projects.

Jim K.

jim@jimkrausedesign.com

CREATIVE CORE
BOOK**02**

Color for Designers is the second book in the New Riders Creative Core series.

The first book in the series, *Visual Design,* deals thoroughly with principles of aesthetics, composition, style, color, typography, and production.

A third title, *Lessons in Typography,* is due on the shelves in 2015. Keep your eyes open for more offerings from this series in the future.

CHAPTER 1

Color 101+

1 LIGHT

All color comes from light. Scientifically speaking, colors visible to the human eye are oscillations of electromagnetic energy with wavelengths measuring from about 400 to 700 nanometers. White light is a mixture of all colors. Black is the absence of light.*

Every color we see is the result of certain wavelengths of light being either absorbed or reflected off things like plants, animals, cars, paisley ties, and plaid skirts.

When white light bounces off the surface of a stop sign, for example, every wavelength of the visible spectrum—except for those of about 650 nanometers (otherwise known as *red*)—are absorbed by molecules of the sign's paint: The wavelengths of red light bounce off the sign's painted surface, travel into our eyes, and are received by photoreceptors at the back of our eyeballs which work with the brain to give us our notion of red.

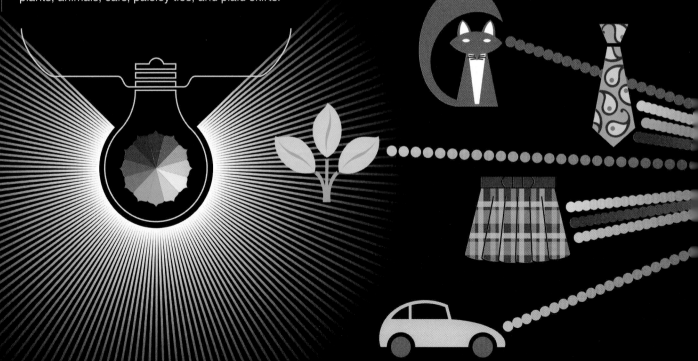

Colors are affected by the properties of the light sources that deliver them to our eyes. A stop sign placed under a green light, for example, would appear gray. This is because green light contains no red wavelengths of light and therefore all of its color-producing wavelengths would be absorbed into the sign's painted surface: None of the light would be delivered to our eyes as color information. (Interestingly, a viewer of a stop sign under these conditions likely still would see the sign as red, but this is only because our brains have learned to used clues—like the shape of a stop sign—to guess the color of certain objects when color information is limited.)

It's not essential for an artist or a designer to fully understand scientific explanations of electromagnetic energy, photoreceptors, or human perception in order to work comfortably with color. It is helpful, though, to clearly understand that all color begins with light, that light can itself be white or colored, and that our perception of color is derived from information gathered by our eyes and assessed by our brains. Knowledge of things like these can't help but give us a good foundation on which to build our ability to accurately evaluate the colors we see and to effectively apply color to our works of design and art.

*When dealing with light, white is indeed the presence of all colors and black is the absence of illumination. As far as paints and inks are concerned, however, it's the other way around: White is the absence of pigments and black is a combination of all pigments. Most of this book's content deals with color theory as it applies to paint and ink. See page 26 for more about the differences between light-based and pigment-based color theory.

2 WHEELS OF COLOR

The first thing to know about the color wheel is that it is an extremely practical and versatile aid for working with color.

The second thing to know is that the color wheel doesn't really exist. Not in the way a rainbow exists in nature, anyway, or in the way illuminated bars of color exist on the wall of a science lab when light has been projected though a prism.

What the color wheel is, is this: A time-tested and painter-approved schematic that artists can not only refer to when formulating a singular color but also when coming up with attractive pairs and sets of colors.

In spite of its non–naturally-occurring and human-contrived roots, you'll see the color wheel employed throughout this book to demonstrate principles of color. And why not? No other method of describing and presenting ways of formulating colors—and also means of combining colors—comes close to matching the centuries-old pedigree of the standard color wheel built around primary, secondary, and tertiary colors (all of which are explained on the pages that follow).

The color wheel featured at the top of the facing page is of the standard sort: solid spokes of primary, secondary, and tertiary colors. The other two wheels are built from the same colors, and these wheels take into account the fact that colors can either be bright or muted and that colors can also be presented as either light or dark. It is because all three qualities of color (hue, saturation, and value—covered on page 32) cannot be presented in a single two-dimensional color wheel that the three wheels at right are so essential.

A standard color wheel based on the primary colors of red, yellow, and blue. When looking at a basic color wheel like this, it's important to keep in mind that each of its spokes should really be thought of as placeholders for larger sets of colors. For example, the red-violet spoke should be thought of as a representative of all lighter, darker, brighter, and muted versions of red-violet. Viewing the color wheel in this way is essential when coming up with the individual members of palettes such as those featured in Chapter 3, Color Relationships, beginning on page 46.

RED

RED-VIOLET

RED-ORANGE

VIOLET

ORANGE

BLUE-VIOLET

YELLOW-ORANGE

BLUE

YELLOW

BLUE-GREEN

YELLOW-GREEN

GREEN

This color wheel includes different degrees of saturation (brightness, or intensity) for each color. Saturation is discussed on page 32.

Each slice in this wheel features its color in a full range of values—from light to dark. Value is the subject of Chapter 2, Value Over All, beginning on page 28.

3 PRIMARY COLORS

Red, yellow, and blue are the three primaries of the color wheel.

Primary colors are *source* colors, and as such cannot be made through mixtures of other colors: There is no yellow or blue in red, no red or blue in yellow, and blue contains not a trace of either red or yellow.

When primary colors are mixed, they create all secondary and tertiary colors with names like orange, green, and blue-violet, as well as produce colors that have less precise names like chartreuse, salmon, periwinkle, mahogany, dandelion, or peanut butter.

Throughout this book—except where otherwise noted—you'll find statements about the behavior of colors from a theoretical point of view. In actuality, the real-life pigments that are used to make paints and inks are subject to the whims of impure ingredients and chemical reactions that generally cause slight differences between the ways colors behave in the real world compared with the ways they behave in theory.

RED
RED-VIOLET
VIOLET
RED-ORANGE
ORANGE
YELLOW-ORANGE
BLUE-VIOLET
YELLOW
BLUE
BLUE-GREEN
YELLOW-GREEN
GREEN

COLOR 101+

4 SECONDARY COLORS

Secondary colors occur when primaries are mixed: Red and yellow make orange; yellow and blue make green; and blue and red make violet.

With secondaries added to the wheel, it's possible to begin seeking complementary associations between colors. Complementary colors sit directly opposite each other on the color wheel. (See Complementary, page 54 for more about pairs of this kind.)

18

Even with just six spokes of the color wheel filled in—spokes containing primary and secondary colors—great potential already exists for coming up with attractive pairs and sets of colors.

The image at right contains both primary and secondary colors. The colors appear at full strength in some cases, and in other instances they show up as lightened, darkened, or muted versions. The illustration's palette of grays also comes from one color wheel's spokes: These grays are actually highly muted incarnations of yellow (see pages 42 and 82 for more about muting colors and the nature of grays).

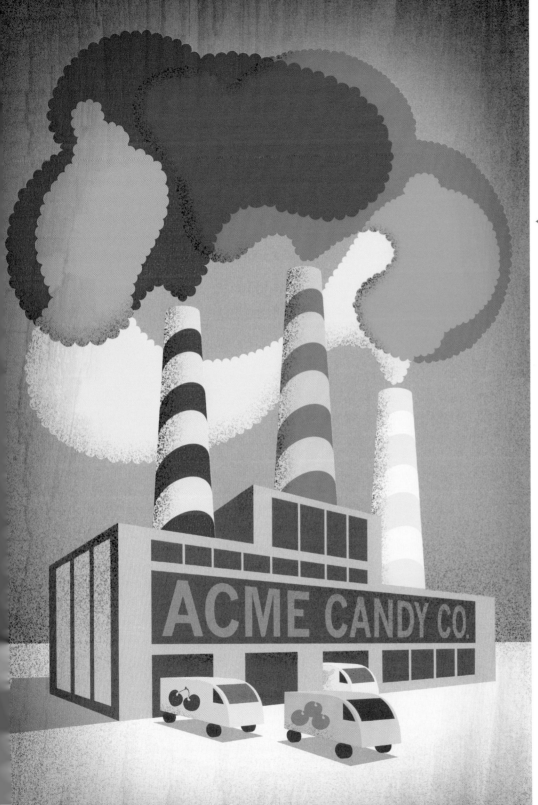

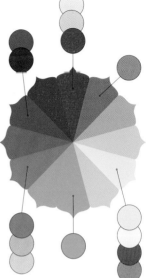

Each of this image's colors originated from primary and secondary spokes of the color wheel. Some of the colors have been lightened, some have been darkened, and one has been strongly muted to create grays.

The graphic directly above illustrates the spoke of the color wheel from which each of the image's colors originated. The light, dark, and muted versions of each color were found using Adobe Illustrator's Color Guide panel (more about this helpful color-choosing tool on page 44).

5 TERTIARY COLORS

Blends between primary and secondary colors produce tertiary colors.

You can give tertiary colors names like chartreuse, teal, or autumnal orange, but since labels like these are so heavily affected by personal interpretation, many designers and artists prefer to stick with less ambiguous names for tertiaries: names like blue-violet, violet-red, red-orange, orange-yellow, yellow-green, and green-blue.

And even this system of vocabulary leaves itself open to questions like, *Is blue-violet different from violet-blue?* The answer, of course, depends on who you ask, but the consensus among art professionals seems to be that whichever color appears first in the hyphenated name of a tertiary color is the one that is slightly more evident. For example, according to this naming convention green-yellow would tend toward green more strongly than yellow-green.

20

It's important to understand that the language of color is far from absolute. Words like red, blue, and green are relatively agreed upon, but even so, if you were to ask ten people to show you their idea of true red, you would almost certainly get ten different answers. And when words like salmon, mauve, and cinnamon are brought into the conversation, definitions are almost certain to get even less precise—if not downright ambiguous.

A suggestion: Keep your color vocabulary as simple as possible when aiming for clear communication with designers, artists, printers, and clients. Use descriptors like bright yellow-green and muted red-orange, for example, in place of words like chartreuse and cinnamon. Labels like chartreuse, cinnamon, coral, and persimmon are not out of bounds, but they are perhaps best suited for situations where you're seeking emotional or literary conveyances in place of visual accuracy.

Anything is possible when working with a full range of primary, secondary, and tertiary colors—especially when you include dark, light, muted, and bright versions of some or all of the colors. We'll cover much more about using a fully-stocked color wheel to create effective palettes in the pages ahead.

6 HSV: THE ANATOMY OF A COLOR

All colors can be defined in terms of their hue, saturation, and value (HSV). These *three* qualities define the look of every color: just these three and always these three.

This is good news for designers and illustrators who work with color. After all, if any color can be identified and described in terms of just three characteristics (versus say, five, twelve, or a hundred characteristics), then doesn't this remove a great deal of the supposed mystery behind formulations of color and the creation of good looking palettes?

Begin recognizing these qualities in the colors you see and use when working on professional and personal projects. Looking at colors simply in terms of their hue, saturation, and value will make things easier when making adjustments to—and seeking appropriate companions for—any color or group of colors.

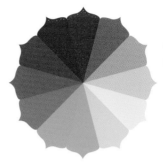

Most of the color wheels featured thus far in this book have been wheels of hues.

Hue is a color's spoke on the color wheel, for example, the blue spoke, the green spoke, the blue-green spoke. Hue is another word for color (and from here on in this book, you'll see the words *hue* and *color* used interchangeably).

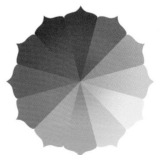

This color wheel includes different levels of saturation for each hue.

Saturation refers to the intensity of a hue. Saturation is also sometimes referred to as chroma, richness, or purity. A hue in its most intense form is fully saturated. A hue that has been dulled or muted is less saturated.

22

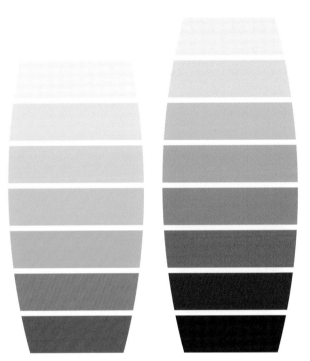

Value is the darkness or lightness of a hue on a scale that runs from near black to near white. Hue, saturation, and value are each crucial considerations when choosing and applying colors, but value has to be consideration number one since neither hue nor saturation can exist without a value to latch onto. (Read more about the critical qualities of value in the next chapter.)

A truly complete color wheel would need to be represented in three dimensions—as some kind of color sphere, cone, cube, or freeform 3D shape. Dimensional color models are not currently available in hands-on desktop form, but who knows, maybe holographic imagery (or something along those lines) will make 3D color aids commonplace tools for designers in the years ahead.

7 WARM AND COOL

Warm and cool are very useful terms when it comes to thinking about—and talking about—color.

Warm colors—intuitively enough—are those that range among and between the red, orange, and yellow spokes of the color wheel. Cool hues span from violet to green. Borderline colors like yellow-green and red-violet might be considered either warm or cool depending on the relative warmth or coolness of nearby hues.

Warm and cool can also pertain to specific hues. Certain reds, for example, may appear warmer or cooler than other reds. (Warmer reds are usually those that lean toward red-orange and cooler reds generally have hints of violet).

Why are these distinctions important? For one thing, they help when communicating thoughts about color, as when one designer asks another, *Wouldn't that red headline stand out better if it were a touch warmer?* And when the other designer replies, *Yep, and if we use a warmer red for the headline, we could also help it stand out by setting it on top of a pattern of neutral hues.*

Warm colors tend to attract more attention than cool hues (which is exactly why street signs with urgent messages are generally either red, yellow, or orange). Keep this in mind when applying colors in ways that are meant to help guide viewers' eyes through the components of a layout or an illustration (see Guiding with Hues, page 102).

COOL COLORS

WARM COLORS

Grays can also be warm or cool. Warm grays are those that tend toward yellow, orange, or red. Cool grays are those that lean toward violet, blue, or green. (Find out more about warm and cool grays on page 82.)

Warm and cool colors produce different thematic effects.

A lively and vibrant collection of warm colors boosts this abstract illustration's conveyances of action and energy.

Connotations of a more relaxed and soothing nature are delivered when the same illustration is colored with cool hues.

Want to add notes of com-plexity and sophistication to an image? Try using colors that are variously warm, cool, bright, and muted.

8 ADDITIVE AND SUBTRACTIVE COLOR

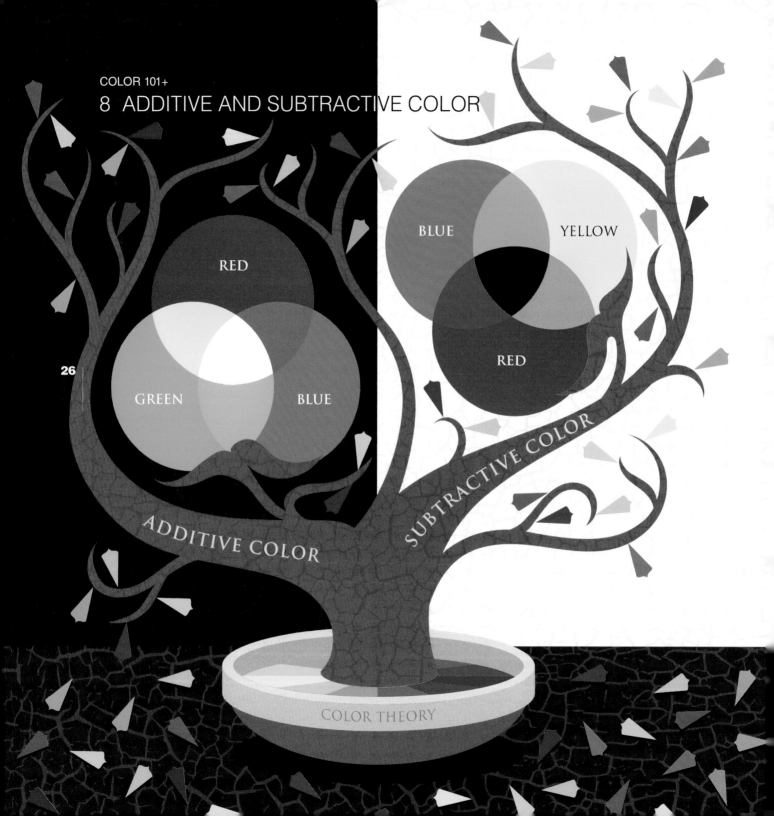

26

RED

GREEN

BLUE

BLUE

YELLOW

RED

ADDITIVE COLOR

SUBTRACTIVE COLOR

COLOR THEORY

There are two main branches of color theory: additive and subtractive. Additive color theory applies to light. Subtractive color theory applies to physical media like paints and inks.

Subtractive color lies at the foundation of the color-wheel concepts presented earlier in this chapter and throughout most of this book. Nearly all designers and illustrators—whether they know it or not—work exclusively within the parameters of subtractive color: The paints and inks that are employed when creating works of art and design abide by subtractive color theory, as do the colors within programs like Photoshop, Illustrator, and InDesign (unless instructed to do otherwise).

Additive color, as mentioned above, applies to light, and light behaves very differently than do paints and inks. With light, the primary colors are red, green, and blue (RGB, for short). Full amounts of all three primary colors of light produce white and the absence of all three equals black. Secondary colors of the additive color wheel are yellow, magenta, and cyan (as seen in the interior colors of the additive color wheel at left).

Do designers need to understand light-based additive color theory? It's not an absolute must, but it certainly doesn't hurt to know that colored light behaves differently than colored pigments. This knowledge will help a designer who, for instance, is wondering why light-based RGB color wheels and color charts follow a different logic than pigment-based guides, and it might also come in handy if a designer happens to land a gig that involves directing the use of colored lights for something like a photoshoot or a stage production.

28 | CHAPTER 2

Value
Over All

9 NO VALUE, NO COLOR

Some designers and artists operate under the assumption that hue, saturation, and value are equally important when it comes to creating colored images or layouts. These people are mistaken.

Value must be thought of as more critical than either hue or saturation. Why? Because hues cannot even exist without value. And levels of saturation cannot be applied without hues. Both hue and saturation, therefore, need value in order to occur. Period.

Value, on the other hand, needs neither hue nor saturation. Want an example of this? Look no further than a black-and-white photograph. Black-and-white photos are nothing but an arrangement of values. Hue and saturation never enter the picture (so to speak).

This isn't to say that hue and saturation are unimportant. Far from it. Colors themselves are products of hue and saturation. Values simply

give colors an environment in which to reveal their enchanting, intriguing, and mood-altering conveyances.

Another great thing about values—in addition to giving hue and saturation places to show themselves—is that they tell the brain what the eye is looking at: Value determines the forms of everything we see. In fact, the brain is so biased toward values that when looking at an image of a person, an animal, or an object, the brain will rarely have any trouble understanding what the eyes are seeing regardless of what colors have been applied to the image. The two illustrations at right demonstrate this bias: Both images are perfectly recognizable as human faces in spite of the fact that they make use of palettes that are anything but true-to-life. What this means to cleverly opportunistic and open-minded designers and illustrators is that there are an abundance of theme-generating, mood-inspiring, and effect-generating ways of applying color to illustrations and photographs—as long as the images' values make sense to the eye.

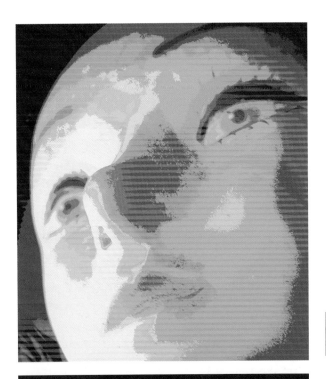

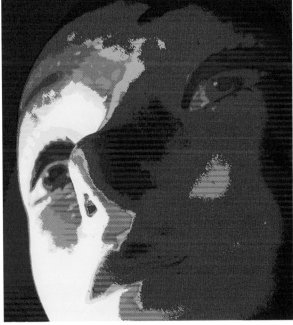

10 HUE, SATURATION, AND VALUE, TOGETHER

Inexperienced designers often lean toward combinations of hues that have similar (and often fairly bright) visual characteristics. It's almost as though these designers have applied colors by squeezing them straight from the tubes of a basic set of paints.

And while this off-the-shelf look sometimes hits the mark (as when designing for younger audiences, sports teams, and clients in search of an extroverted and energetic look or message), it's an approach that seldom generates visuals that are strong on complexity or sophistication.

When developing color combinations, learn to start with basic color-wheel associations (covered thoroughly in the next chapter) and to then consider using darker, lighter, or brighter versions of one or more of your palette's hues: Rare is the accomplished designer or illustrator who does not seek the full aesthetic and thematic potential of the specific value,

hue, and saturation of every color they include in their works of art and design.

If you have an illustration annual nearby, open it up and take a look at the creations of the talented artists showcased inside. In addition to finding that there is a great deal of variety among the work of the annual's featured artists, you will almost certainly discover (especially when looking at more contemporary examples of illustration) an abundance of images that have been colored according to a solid value structure, an eye-catching selection of hues, and a beautiful variety of saturation levels.

Get in the habit of considering all three characteristics—hue, saturation, and value—of every color you apply to the layouts, graphics, and illustrations you create. Like most habits, this is one that will become second nature if regularly employed.

Consider your options when deciding how to apply levels of saturation to graphics and illustrations.

The upper illustration in this pair has been filled with an almost uniformly intense selection of hues.

Only a few of the lower image's colors have been allowed to show up at full intensity. The rest of its hues have been muted to create a palette of supporting neutral tones.

Either of these coloring solutions could be considered correct. The upper solution, because of its bright and lively coloring, might be used when younger or more action-oriented audiences are being addressed. The lower illustration, through its more restrained presentation of color, might be better suited for situations that call for a more thought-provoking or sophisticated presence.

11 VALUE AND HIERARCHY

UNIVERSITY SPEAKER SERIES

the

ROAD TRIP

JOURNALS

Lorem ipsum dolor sit amet, consectetur adipisicing elit, sed do eiusmod tempor incididunt ut labore et dolore magna aliqua.
Ut enim ad minim veniam, quis nostrud exercitation ullamco laboris nisi ut aliquip ex ea commodo consequat. Duis aute irure dolor in reprehenderit in voluptate velit esse cillum dolore eu fugiat nulla pariatur. Excepteur sint occaecat cupidatat non proident, sunt in culpa qui officia deserunt mollit anim id est laborum.

LOREM IPSUM DOLOR SIT AMET

Eyes are busy little organs. Eyes appreciate being smoothly directed to a composition's most important elements before being guided toward components of lesser importance. When the eye gets frustrated in this regard, it usually doesn't take long before it grows impatient and moves on to other business.

Value plays a critical role when it comes to delivering a strong sense of visual hierarchy: Areas of a composition that feature strong contrasts in value tend to call for more attention than areas that present themselves through moderate or mild value contrast.

Look at the portraits done by great Renaissance painters and you'll see value contrasts at work: These portraits' main subjects are almost always presented solidly in the foreground of the paintings through hues with strong differences in value. The mountains, trees, and clouds beyond the portrait's subject, on the other hand, will likely have been presented though a palette that features much lesser differences in value. (Naturally, you'll also see that hue

and saturation play important roles in directing the eye through these painterly compositions—more on these aspects of visual hierarchy can be found on page 102, Guiding with Hues).

You can apply these same value-based strategies of visual hierarchy to layouts as well. For example, if you want the image in your layout to call loudest for attention, then see to it that the range of values—and the degrees of value contrast—within the image are stronger than those that appear elsewhere in the design. And if your layout's headline should be the next thing viewers' eyes are attracted to, then take pains to ensure the value contrast between the headline and its backdrop are greater than value differences seen in less important areas of the layout.

A layout's colors, size relationships, and overall positioning of elements each play a part in establishing a sense of visual hierarchy that will lead viewers' eyes comfortably and sensibly through a composition's components. Color, of course, is the focus of this book while compositional factors such as size and placement are covered in depth in this title's Creative Core companion volume, *Visual Design*.

12 VALUE AND MOOD

Value, as mentioned on page 31, helps the eye understand what it's looking at. Value can also assist the eye and the brain in determining the order of importance of a composition's elements (as talked about on the previous spread). There is yet another role that value can play in terms of a piece's visual impact, and that's when it functions as the deliverer of thematic and emotional conveyances.

Compositions with a strong presentation of values that range from dark to light are especially capable of delivering conveyances of liveliness and action. This is particularly true when layouts and images with wide-ranging values are also colored with an energetic collection of saturated hues that confirm the upbeat nature of the rest of the piece's visual and textual content.

Palettes whose colors lean toward darker values tend to transmit a more subdued feel. The look could be one of sophistication, moodiness, or edginess depending on the specific content and colors that have been applied to the layout or image in which they appear.

Quiet suggestions of sensitivity or luxury can result when a piece's colors tend toward lighter values. And, as with other value structures, the conveyances of a light-value palette will gain a boost when they are applied to similarly themed visuals.

An awareness of the theme-generating effects of value can be very useful when fine-tuning the look of a work of design or art. If, for instance, a layout is shouting when it should be whispering, try reducing the contrast between its color's values (and also, perhaps, try muting the saturation of some or all of its hues). And if an illustration needs to shout, but seems to be holding back for some reason or another, try elevating its colors' value differences (along, very likely, with some of its colors' saturation levels).

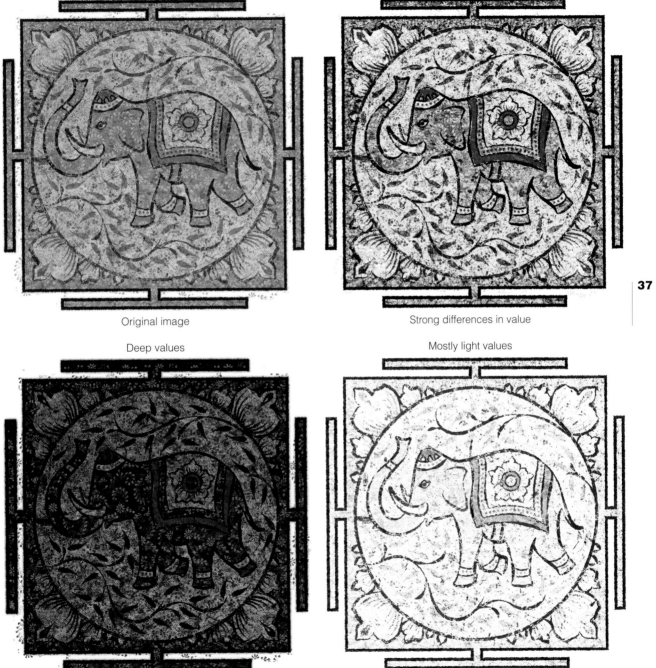

Original image

Strong differences in value

Deep values

Mostly light values

13 KEYING PALETTES

Designers, illustrators, and photographers are often encouraged to include a full range of values in their works of design, art, and photography: values that range all the way from black (or very nearly black) to white (or nearly white). This is solid advice and it's generally worth paying attention to. A wide range of values allows a great deal of latitude when working toward most any visual and thematic outcome.

There are, however, situations that call for layouts and illustrations that have been colored with hues that are limited to a narrow range of values. These palettes are often described as *keyed*: High-key palettes are those that contain *only* lighter values and low-key palettes are those with *only* darker values.

You can choose keyed palettes for purely practical reasons. Backdrop patterns, for example, generally function best when they are colored with a keyed palette: You can effectively apply a high-key palette—because it's made up of consistently light

colors—to background patterns or images that sit beneath dark text; similarly employ a low-key palette to produce a consistently dark backdrop for light text.

You can also create mood through palettes that have a restricted range of values: High-key palettes are frequently used when messages of a comforting or nurturing feel are being sought; low-key palettes are often seen within media that is meant to convey feelings of a pensive or sinister nature.

Keep your eyes open for effective examples of layouts, illustrations, and photographs that are presented through keyed palettes: high or low. Take note of how the creators of such pieces have handled the sometimes challenging task of achieving visual clarity while working within a narrow band of values, and also make mental notes of the stylistic and thematic outcomes the pieces generate. This is good information to have in the brain when exploring options for projects of your own.

14 DARKENING COLORS

With all this talk of color theory and values, some real-world, fundamental questions may be coming to mind. Like, *Exactly how do I darken a color? Do I just add some black? Do I add gray or brown? Do I add a touch of the color's complement?*

40

Being art-related, it should come as no surprise that there are several different ways of answering these questions—and none of the answers are all that concise. In general, however, it could be said that most painters use at least one of the following three methods of color-mixing to deepen a hue. (Specific software-related color-altering strategies are covered on pages 44–45).

1: Add black or an appropriately dark shade of gray to darken a color. This method tends to deaden the look of a color as it darkens it, but it can also produce stylistically intriguing results.

2: Blend a color with its complement (or add a touch of black or dark gray to the mix if a hue's complement is too light to act as a darkening agent).

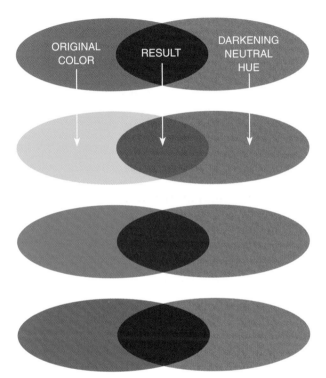

3: Choose an in-common dark neutral color (a dark brown, a dark warm gray, or a dark cool gray) and use it as a darkening agent for more than one hue whose value needs to be deepened. This color-darkening strategy can help produce a palette with strong projections of visual and stylistic agreement through the visual influence of its in-common darkening hue.

Additionally, it's important to note that experienced painters allow themselves plenty of well-deserved artistic license to add touches of whatever color suits their fancy when applying any hue-darkening strategy. (See What Color Is a Shadow? on page 110.)

Some designers and digital illustrators never actually handle paints. This is unfortunate since a fundamental awareness of paint-based color-altering strategies can give any computer-using art professional a great deal of insight when seeking accurate ways of altering CMYK or RGB formulas, when using printed or on-screen color charts to select alternate versions of specific hues, when consulting a spot-color guide (a Pantone guide, for instance) in search of color options, and when deciding among the on-screen choices offered through digital aids such as Illustrator's Color Guide and Adobe's Color Picker (available within Photoshop, Illustrator, and InDesign). See Chapter 13, Paint? Paint! beginning on page 210 for more about the idea of handling and learning from real-world pigments.

15 LIGHTENING AND MUTING

When painters want to lighten a color, they generally add white. Often, they'll modify this white by giving it either a warm or a cool tint—depending on the visual qualities of the perceived source of light within their work of art.

Another simple and practical way artists lighten colors is by thinning their paint with a solvent or a clear medium to allow the lighter color of the painting's underlying surface to show through.

You can lighten printing inks by printing them as screened tints. This is old news to anyone who has worked much with spot-color and process-color printing. CMYK color formulas can also be lightened, darkened, or muted by using and consulting digital tools such as those mentioned on the following spread.

When muting a color, painters generally mix in a bit of the color's complement plus, optionally, a bit of

gray, black, or brown. And, unsurprisingly, the values of muted hues are usually adjusted by adding white, gray, black, or brown.

Designers may find Illustrator's Color Guide panel (covered on the next spread) helpful when seeking lighter, darker, and more muted versions of hues that are being applied to a layout or an image. Try it out—but also challenge yourself to come up with your own lighter, darker, and more muted CMYK and RGB variants when creating digital works of design and art. The experience gained when devising custom-made adjustments to CMYK and RGB formulas supplies the eye and the brain with valuable intellectual and practical information—mental data that will almost certainly lead to a better understanding of the ways of color.

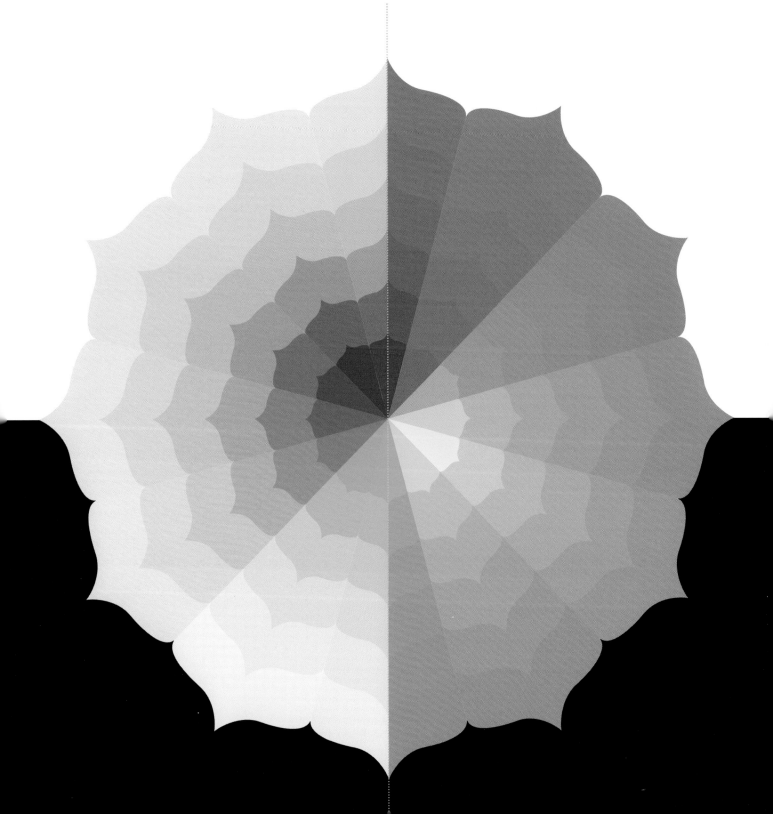

16 DIGITAL COLOR AIDS

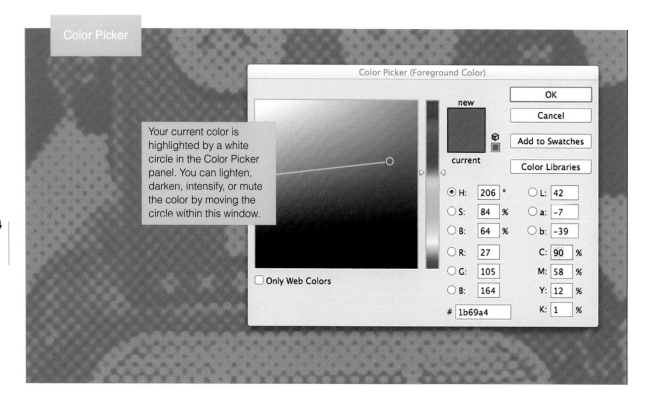

Color Picker

Color Picker (Foreground Color)

new

current

OK

Cancel

Add to Swatches

Color Libraries

Your current color is highlighted by a white circle in the Color Picker panel. You can lighten, darken, intensify, or mute the color by moving the circle within this window.

☉ H: 206 °
○ S: 84 %
○ B: 64 %
○ R: 27
○ G: 105
○ B: 164

○ L: 42
○ a: -7
○ b: -39
C: 90 %
M: 58 %
Y: 12 %
K: 1 %

☐ Only Web Colors

1b69a4

Photoshop and Illustrator offer handy tools that can help you come up with lighter, darker, brighter, and more saturated versions of CMYK and RGB colors.

The Color Picker available through both Photoshop and Illustrator is one such tool, and the Color Guide featured in Illustrator is another. Both of these tools' control panels are shown on this spread.

Keep in mind, always, when using digital color aids like these, that your eye and your color sense are the final referees when it comes to choosing and finalizing the hues of your palettes. Think of the solutions offered though tools like the Color Picker and the Color Guide as *suggestions*—and if you don't like the look of the colors these tools suggest, then adjust them as you see fit.

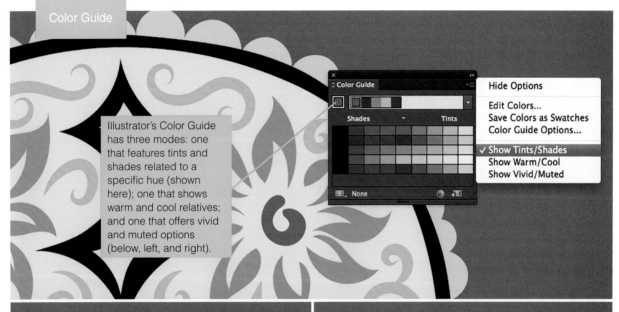

Illustrator's Color Guide has three modes: one that features tints and shades related to a specific hue (shown here); one that shows warm and cool relatives; and one that offers vivid and muted options (below, left, and right).

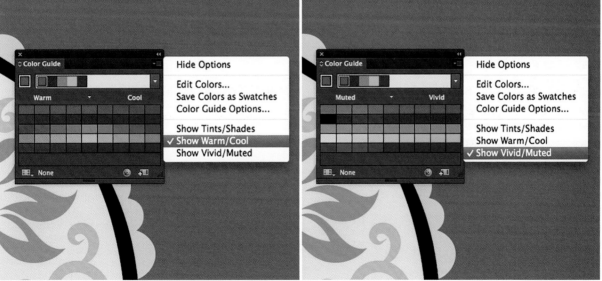

CHAPTER 3

Color
Relationships

17 MONOCHROMATIC

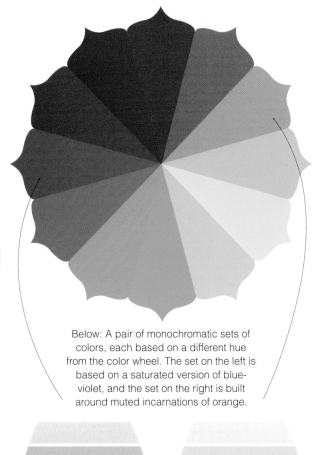

Below: A pair of monochromatic sets of colors, each based on a different hue from the color wheel. The set on the left is based on a saturated version of blue-violet, and the set on the right is built around muted incarnations of orange.

Perhaps the color wheel's most useful function is that of being able to convey easy-to-understand—and easy-to-remember—visual relationships between hues. It's possible to make simple color-wheel schematics of all of the color relationships featured in this chapter—except for one. This one. *Monochromatic* sets of colors—being simply a set of lighter and darker versions of a single hue—can be better visualized though simple stacks of colored values like those featured at lower left.

Technically, a monochromatic palette can include any number of tints (lighter versions of a color) and shades (darker versions). The eye, however, has trouble seeing differences between the members of monochromatic palettes that have more than seven or eight components, so it's rarely necessary to include more than that.

Monochromatic palettes are effective for setting a tone of both economy and purpose. *Economy,* not necessarily in the monetary sense of the word, but rather in the sense of much being done with little. And *purpose* in the sense that the stylistic and thematic messages of the palette's parent hue are amplified by the inclusion of several of its like-minded relatives.

Monochromatic palettes may be your only choice if you're working on a print job where you're allowed to use just one color of ink, or one color plus black: You can create lighter tints of the color by printing the colored ink as various halftone percentages, and—if you're also using black ink—you can create darker versions of the color by adding tints of black to either solid shades of the colored ink or its halftoned tints.

Present photographic images, too, as mono-chromatic images. Make sure to choose a color that is dark enough to provide an adequately broad range of values when coloring photos in this way.

You can color abstract, representational, realistic, and stylized illustrations effectively and attractively with monochromatic palettes.

18 ANALOGOUS

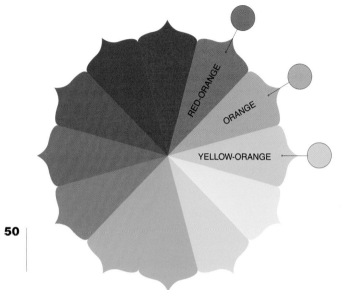

Two analogous
palettes

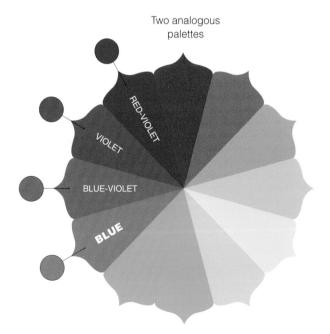

Combinations of three to five adjacent hues on the color wheel form *analogous* sets.

Analogous palettes are well suited for conveying themes of agreement and support, since all of their members are neighbors and near-neighbors on the color wheel.

This isn't to say analogous color schemes cannot generate moderate hints of diversity and opposition. Of course they can: The healthy difference between the first and last color of an analogous strip of hues (especially those that contain four or five members), and the potential of applying notably different values and levels of intensity to each hue in an analogous palette, allow plenty of leeway in terms of establishing themes that come across as either sympathetic or discordant.

Is an analogous color scheme a good choice for your project? It's easy enough to find out if you're working digitally: See Seeding Multicolor Palettes on page 72.

Choosing the foundational members of an analogous palette—
or when selecting foundational hues for any of the palettes
shown in this chapter—is only the beginning of that palette's
journey toward refinement: Each hue of the color-wheel-based
palettes shown in this chapter can be darkened, lightened,
muted, or brightened without violating the definition of that
palette. For instance, you could modify an analogous trio of
blue-violet, blue, and blue-green by presenting the blue-violet
in both a dark muted and a light-and-bright version, including
dark and light variations of the blue, and featuring a muted and
a lightened incarnation of the blue-green—all without upsetting
the definition of an analogous palette.

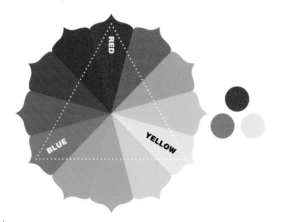

Three triadic associations

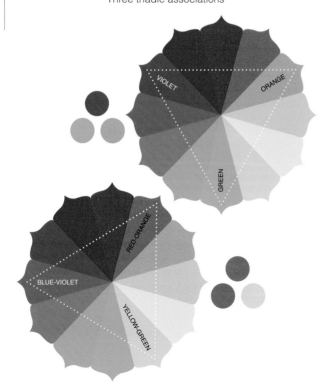

Triadic palettes are built from three hues that are equally spaced around the color wheel. Red, yellow, and blue are a triadic set of hues. Violet, orange, and green also form a triad, as do blue-violet, red-orange, and yellow-green.

No three hues of the color wheel can be spaced more widely—and therefore be more visually diverse—than those belonging to a triadic palette. It stands to reason, then, that you can generate charismatic and energetic conveyances of plurality and divergence through triadic sets of hues. Emphasize these conveyances by employing extreme differences in the values and/ or levels of saturation within the palette, or soften them by limiting the amount of contrast between the palette's values and/or its levels of saturation.

The only truly bright incarnations of the hues used in this illustration appear within the ice-cream bar's interior and around the monkey's mouth. All the other hues have been muted to help ensure that the areas containing the most saturated colors call for slightly more attention than other areas of the illustration. The overall predominance of muted hues in the illustration is also useful in lending a slightly nostalgic feel to the piece.

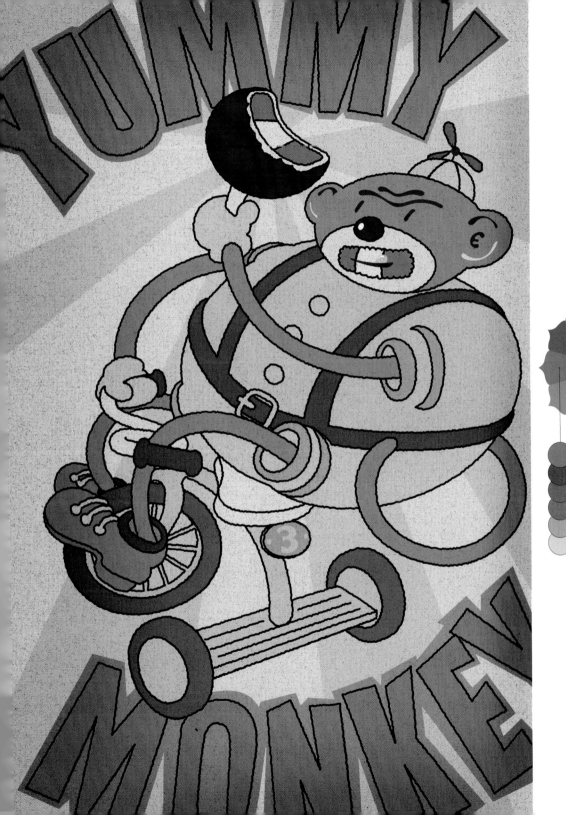

53

20 COMPLEMENTARY

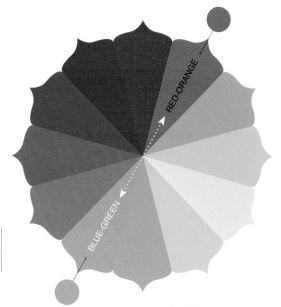

A complementary pair of hues

Complementary colors—in spite of the congenial-sounding name given to these pairs of hues—come from directly opposing spokes of the color wheel and have absolutely nothing in common.

Fortunately, with color, it's not at all important that hues have anything in common in order to pair nicely. In fact, any two colors—complementary hues included—can associate beautifully as long as their values and levels of saturation have been adjusted to meet a project's stylistic, aesthetic, and thematic goals. (See There Are No Bad Colors, page 70, for more about the connection between color, context, and beauty).

Complementary colors can generate spirited inferences of individuality and vitality due to their opposing positions on the color wheel (conveyances of opposition and contrast are very often employed—in one way or another—to assert emphatic thematic declarations in design, painting, music, fashion, architecture, and sculpture).

Still, complementary duos need not always convey themselves in overtly charismatic ways: Projections of visual energy can be tamed by muting the hues of complementary palettes and also by limiting the differences between their hues' values.

Whatever your visual and thematic goals, experiment with options when coming up with palettes based on complementary hues. Try expanding one (or both) of the hues into a set of monochromatic relatives, for example, or try using one of the complementary hues as the basis for a set of dark and muted backdrop colors and the other as a light and bright accent hue.

A caution: It's generally considered a visual faux pas to use a pair of complementary colors that are both relatively bright and are both of the same (or very similar) value: An uncomfortable visual *buzz* often occurs along the boundaries where colors like these meet. (See Dangerous Color, page 78, for more about this and other potentially problematic color choices).

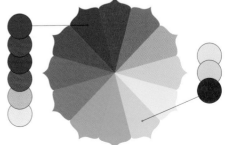

21 SPLIT COMPLEMENTARY

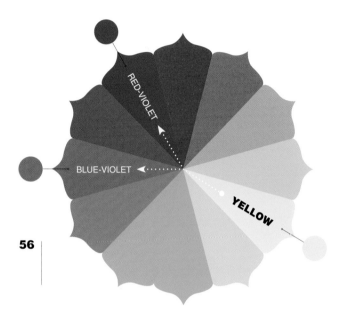

Two split-complementary palettes

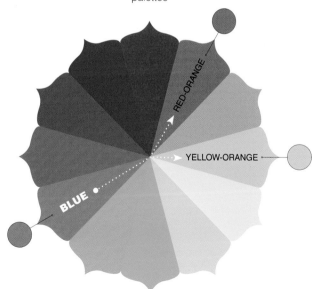

Split complementary palettes are created when a color is joined by the two hues on either side of its complement (yellow, joined by red-violet and blue-violet, for example). Palettes of this kind are uniquely capable of conveying inferences of like-mindedness while simultaneously delivering connotations of dissent.

This sophisticated duality is brought about through the very arrangement of the colors in a split complementary palette—a palette that features two neighborly hues sitting on one side of the color wheel while an opposing color stands defiantly alone directly opposite.

As with this chapter's other palettes, explore variations in the presentation of your split complementary palette's hues by investigating options that include expanding one or more of its components into mono-chromatic relatives and also by darkening, lightening, muting, or brightening some or all of its members.

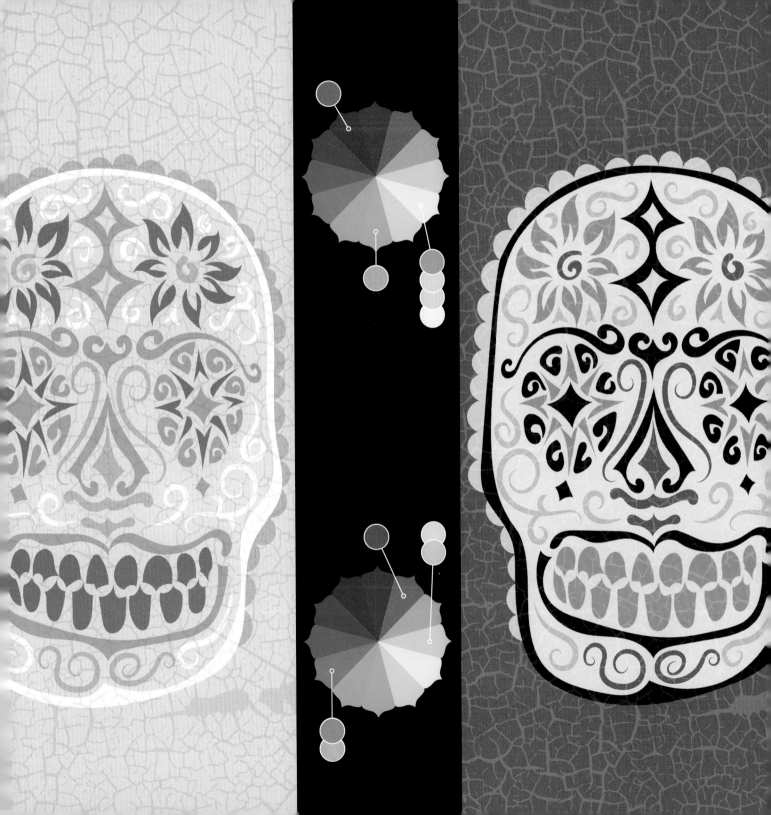

22 TETRADIC

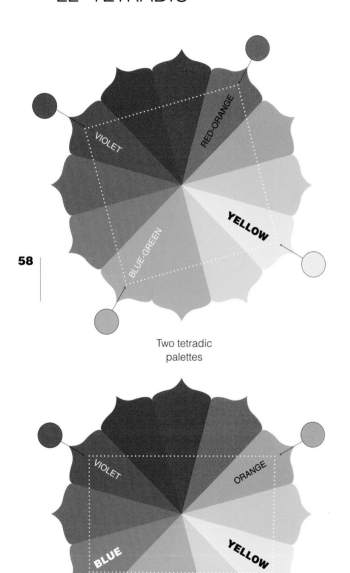

Two tetradic
palettes

Here's a palette that often gets overlooked when color-wheel associations are discussed, but it's still one that's well worth knowing about: *Tetradic* combinations.

A tetrad is a group of four, and tetradic combinations of hues form either squares or rectangles on the color wheel. (Both kinds of tetradic palettes, by the way, feature two sets of complementary hues.)

Tetradic combinations of colors, like triadic combos, have great potential for conveyances of diversity and charisma due to the wide variety of colors they contain. Because tetradic palettes always include two warmer and two cooler hues, take extra care with this kind of palette to ensure that its warmer colors (and possibly its cooler hues as well) do not fight with each other for attention. This is a fairly easy issue to manage: Lowering the saturation of any hue that is calling for too much notice usually takes care of the problem.

23 WHATEVER LOOKS GOOD

Think of these palettes simply as conveniently labeled relationships between hues of the color wheel—relationships that can be quickly understood and easily explored while searching for attractive and effective combinations of color.

An important thing to remember whenever working within the structure of a predefined palette is that there is no empirical rule that forbids you from adjusting one or more of the palette's hues to suit your personal preferences—even if this means pushing the limits of the palette's definition. If the blue in your complementary blue-plus-orange palette would look better if it had just a touch of green, for example, then by all means, add a touch of green.

Some people believe that certain palettes are magically inclined to produce attractive color schemes—monochromatic, analogous, triadic, complementary, split complementary, and tetradic palettes, for instance.

Others think predefined color-wheel associations like these are too dogmatic and restrictive to be part of a freethinking artist's color-picking process.

Really, though, the aforementioned color relationships are neither magic nor restrictive, and their potential for greatness is neither absolute nor negligible.

Trust your color instincts, in other words. And if you don't feel like your color instincts are fully trustworthy at this point, then set about fixing this situation right away. It's really not that hard to do.

For starters, make a point of looking at the work of great artists and designers. Do this by visiting museums, art galleries, and artists' studios, by keeping an eye on the media featured in design, illustration, and advertising annuals, and by looking through books and magazines about both historical and contemporary arts.

Also, study, learn, and experience. Study this book, study other books about color, talk to artists about their use of color, and consider taking a painting class and/or an art history class. And—very importantly—don't forget to practice what you learn (both on the job and on your own): Explore fresh color ideas with every work of design and art you create.

Practical
Palettes
for Designers

24 SINGLE COLOR

Being limited to a single color of ink (a client's official PMS color, for example) and white paper is pretty much the most restrictive guideline a designer is likely to encounter when developing the look of a printed piece.

The good news is that this really does not need to be seen as a restriction at all. You can create eye catching layouts, images, and illustrations with just one color of ink. True, the color needs to be dark enough to stand out clearly against its white backdrop, but given a deep enough hue, the possibilities are many: The colored ink could be broken down into various percentages to create a monochromatic palette, the ink could flood the page at full opacity with typographic and illustrated material either reversed to white or printed at light percentages, and, of course, the ink could simply be used to color a layout whose aesthetic structure and/or textual message are compelling enough to catch and hold viewers' attention.

Photos and illustrations can certainly be printed with one color of ink, especially if they feature a value structure that is bold enough to present itself clearly using something other than black ink.

Be sure to think through the thematic ramifications when pondering the possibility of printing certain images with a single color of ink. You may want to think twice, for instance, before printing a halftone of a banana using bright purple ink (which may or may not be a bad idea—it all depends on whether or not your piece's message is meant to be silly, serious, quirky, or commonplace).

Whatever the case, accept the challenge the next time you're asked to design an eye-catching printed piece using a single color of ink. There are few better ways of proving one's worth and talent as a designer than by rising above the perceived limitations of something like a one-color print job and coming up with top-notch visual material.

elegance

impact

simplicity

25 BLACK PLUS ONE COLOR

66

Designers are regularly asked to come up with layouts that are limited to black and a single color of ink. Business cards, brochures, and posters, for example, often fall into the category of jobs that are to be printed with black and one spot color.

Some designers see limitations like these as restrictions.

Other designers see limitations like these as grand opportunities to demonstrate the power that effective composition, smart color usage, and strong thematic components have in producing intriguing and compelling visuals.

So, which kind of designer are you?

26 PARING COLORS

Take seriously the potential for aesthetic beauty and thematic intrigue even when working with as few as two colors of ink.

Generate connotations of visual energy by combining a pair of saturated hues (just be wary of pairing bright hues with similar values since this can cause the unpleasant visual buzz mentioned on page 78). Also convey visual charisma through strong levels of contrast between the hue, value, and/or saturation of any two colors that you use together.

Lessen projections of aesthetic vigor by restricting the levels of saturation in a pair of colors, and also by limiting differences between the two hues' values.

In terms of printing, keep in mind that there are at least a couple of ways of inflating the appearance of a two-color print job. For one thing, you can always expand each color of ink into a set of monochromatic relatives

by including lighter tints of each color. And—because printing inks are transparent—you may be able to lay your colored inks on top of each other to produce additional hues. A yellow ink, for example, when printed on top of a blue ink, will produce green (exactly what kind of green it might yield might be difficult to predict without paying the printer to run some tests prior to the actual press run, but it will yield a green).

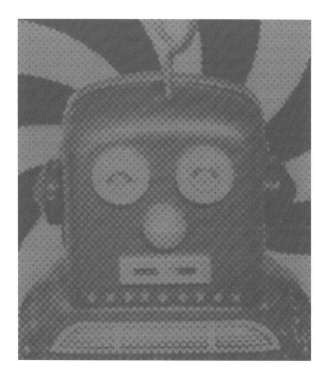

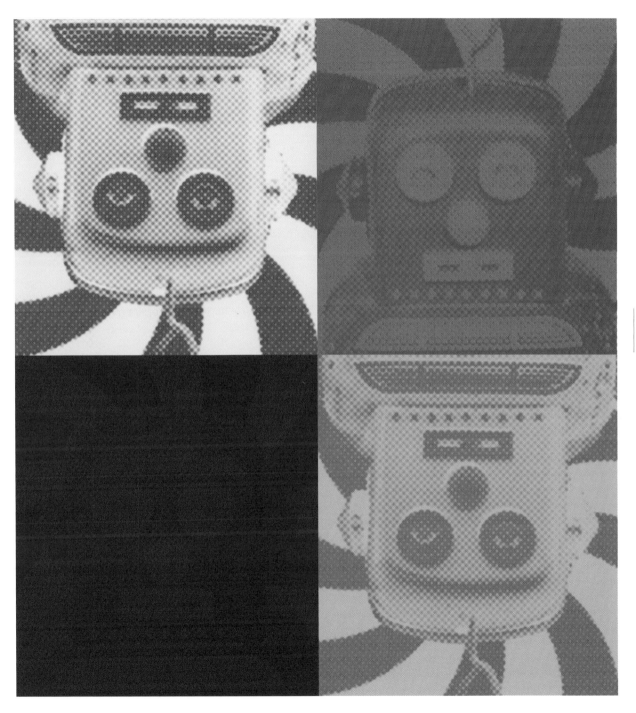

27 THERE ARE NO BAD COLORS

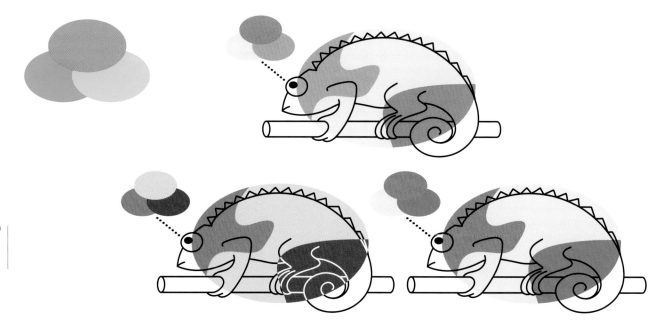

Do the trio of colors shown at top left make a good set? Yes. And no. It all depends on how the designer chooses to present each color in terms of its saturation and value. Using Adobe Illustrator's Color Picker panel it was possible to find variations among these three fully saturated colors to produce the seven color schemes featured above and right.

In design, colors that are perfectly good for one project might be perfectly terrible for another. A deep and vibrant fuchsia that functions beautifully as the corporate color for a contemporary hair salon, for example, might fail miserably if it were applied to the business card of an industrial welding firm.

So really, in the world of commercial art, *there are no bad colors—just bad applications of color.* This goes for individual colors as well as for full palettes of colors. In short, the measure of a color's worth—or a set of colors' worth—lies in how well it appeals to its target audience, how effectively it boosts the client's message, and whether or not it's notably different from the color—or the colors—being used by competing companies. (See Know Your Audience, page 152, for more about seeking effective colors for client work.)

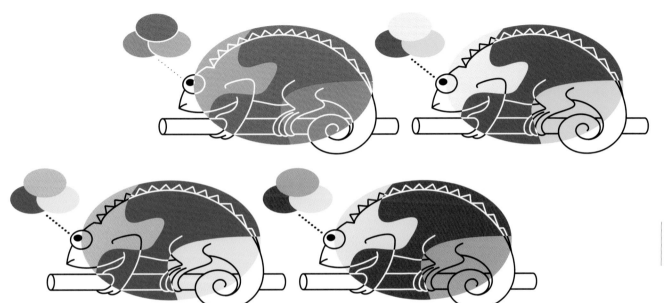

If you've decided on the colors you'd like to apply to a multi-color layout or illustration, and have concluded that the above-mentioned criteria for client-based success has been satisfied by your selection of hues, then there's another principle of effective color usage you'll want to keep in mind as you work: *There are no bad combinations of colors—only bad applications of saturation and value.*

It's true. *Any* set of hues can be made to work effectively as a palette: It's just a matter of making whatever adjustments are necessary to the value and/or the level of saturation of each of the palette's members to ensure the hues look good together and function well as a set. (Chapters 2 and 3 contain plentiful information and ideas about finding and assessing attractive and effective relationships between hues.)

71

28 SEEDING MULTICOLOR PALETTES

Here's a practical, reliable, and versatile way of coming up with palettes that contain multiple hues.

Start with a single color—a hue that seems capable of contributing to your project's aesthetic and thematic goals. This starter color is your *seed hue*, and from this hue your palette will grow.

Locate your seed hue's spoke on the color wheel. To do this—especially if you have chosen a particularly dark, light, or muted version of a color—you will need to employ your art instincts and your knowledge of color to figure out from which spoke of the color wheel your seed hue originated. For example, if your seed hue is a muted pea green, then it probably came from the yellow-green spoke of the color wheel since yellow-green, when muted, becomes what most people consider pea green. (In the end—whether or not your color instincts are well developed at this point—your best guess at the origins of your seed hue will be perfectly sufficient: Scientific accuracy is not a requirement here.)

Next, explore relationships between your seed hue and other colors by employing it as a starter-component of the palettes described in the previous chapter: monochromatic, analogous, triadic, complementary, split complementary, and tetradic. The visuals on the facing page illustrate how you can employ pea green as the seed hue for six different kinds of palettes.

With practice, patience, and experience, your speed and skill at exploring palette possibilities in this way will improve greatly. Also, if you currently use a visual color wheel as you ponder the possibilities of various palettes (and there's nothing wrong with this practice), likely you will find that eventually you'll be able to perform most or all of your palette-building brainstorming mentally— with little or no help from visual guides.

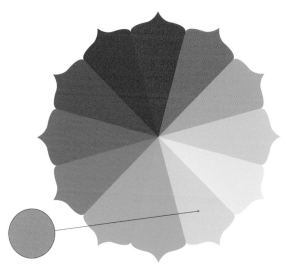

This muted pea green was chosen as the seed color—the starter component, in other words—for each of the six palettes featured on this page.

Monochromatic (page 48)

Analogous (page 50)

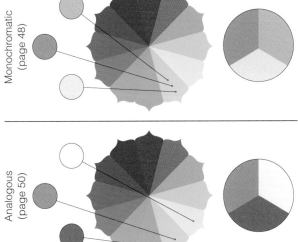

Triadic (page 52)

Complementary (page 54)

Split Complementary (page 56)

Tetradic (page 58)

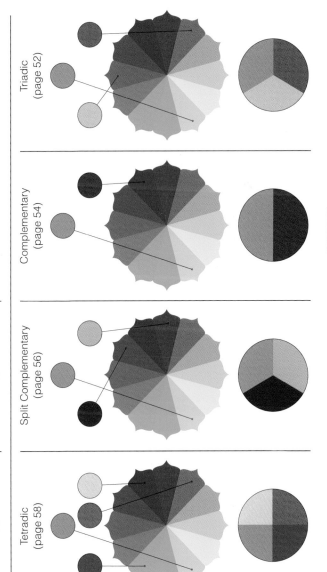

Don't let looks fool you. There is often an easily under-stood rationale behind complex-looking palettes.

Take the hues in this illustration as a case in point. The palette employed here began as a single blue-green seed hue (learn about seed hues on the previous spread). This seed hue became the founding member of a triadic palette. After that, the triad expanded to include at least one darker, lighter, brighter, and more muted version of each of the palette's members before being applied to this spread's illustration. And then, in the interest of generating further connotations of visual complexity, several of the composition's elements were made transparent and allowed to overlap to produce additional hues.

Don't feel intimidated the next time you're tasked with developing a visually complex palette. Start with a seed hue and let things grow (and grow and grow) from there. And also feel free to throw in whatever extra hues you feel like adding (see Whatever Looks Good, page 60, for more on this idea).

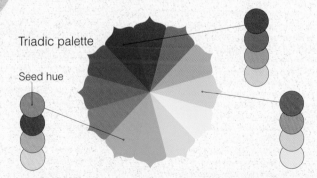

Triadic palette

Seed hue

When is it time to stop adding—or removing—colors from a palette? When the palette has exactly as many colors as it needs to do its job—no more and no less. And when is that? That, of course, is up to you to decide.

30 ESTABLISHING CONNECTION

Digital tools make it easy to establish visual links between color images and other components of the layouts in which they appear.

If you've worked much with Photoshop, Illustrator, or InDesign, then you probably know about the Eyedropper tool. Use this tool to identify and borrow colors from specific parts of an image and apply them to compositional elements elsewhere.

You can borrow a single color, a pair of colors, or an entire collection of hues from an image. You can also employ a color borrowed from an image as a seed hue for a layout's entire palette.

Though it's not always necessary or desirable to borrow and apply colors from a layout's image(s), it is a strategy worth considering when looking for ways of helping an image look at home within the context of a particular layout or work of art.

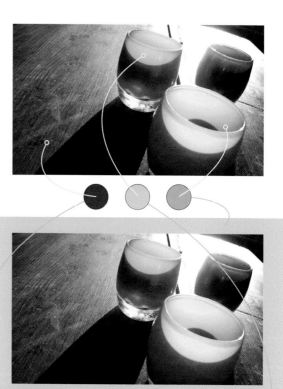

HEADLINE

Lorem ipsum dolor sit amet, consectetur adipisicing elit, sed do eiusmod tempor incididunt ut labore et dolore magna aliqua. Ut enim ad minim veniam, quis nostrud exercitation ullamco laboris nisi ut aliquip ex ea commodo consequat. Duis aute irure dolor in reprehenderit in voluptate velit esse cillum dolore eu fugiat nulla pariatur.

LOGO

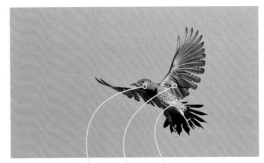

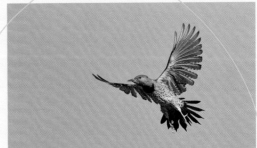

HEADLINE

Lorem ipsum dolor sit amet, consectetur adipisicing elit, sed do eiusmod tempor incididunt ut labore et dolore magna aliqua. Ut enim ad minim veniam, quis nostrud exercitation ullamco laboris nisi ut aliquip ex ea commodo consequat. Duis aute irure dolor in reprehenderit in voluptate velit esse cillum dolore eu fugiat nulla pariatur.

HEADLINE

Lorem ipsum dolor sit amet, consectetur adipisicing elit, sed do eiusmod tempor incididunt ut labore et dolore magna aliqua. Ut enim ad minim veniam, quis nostrud exercitation ullamco laboris nisi ut aliquip ex ea commodo consequat. Duis aute irure dolor in reprehenderit in voluptate velit esse cillum dolore eu fugiat nulla pariatur.

31 DANGEROUS COLOR

On this spread: Four cautionary axioms relating to specific color issues, each followed by a few words in support of or against throwing caution to the wind.

DO NOT confuse the eye by letting hues compete for attention. The eye might feel an uneasy tug-of-war when, for example, contemplating a layout that features a brightly colored headline, a brightly colored illustration, and—you guessed it—a brightly colored backdrop.

EXCEPTION: Go ahead and use colors that fight and bite each other for attention if you're creating a work of art or design that is meant to generate notes of tension, chaos, or celebration gone wild.

DO NOT allow bright complementary hues of the same value to touch. Intense complementary hues that share both a value and an in-common border are notoriously capable of producing an almost palpable visual buzz where the colors meet. Most people find this visual vibration anything but pleasant.

EXCEPTION: If you're trying to capitalize on a resurgence of the 1960s psychedelic look, then yes, by all means, let the same-value complementary hues of your artwork interact with as many shared boundaries as you like.

DO NOT let poor value structure play a part in any work of design or art you create. Value is critical in letting the eye and the brain figure out what's being seen. Good value structure also helps guide viewers' attention in sensible ways throughout the components of layouts and illustrations.

EXCEPTION: There are few—if any—exceptions to this principle. Value simply must be a primary consideration when applying color, and you must make conscientious choices when establishing the values that you'll apply to any work of design or art.

DO NOT use palettes that your target audience will find uninteresting or unattractive. If the colors you apply to your client's promotional and informational material do not resonate with their target audience, then what's the point? Who wins? So get to know your target audience and select a palette that appeals to them. Always. (More about getting to know your audience on page 152.)

79

EXCEPTION: If you're a graphic designer working for a client, there are no exceptions to this principle. If you're a designer or an artist creating a work of art for yourself, then it's up to you to decide whether or not the colors you're using ought to appeal to people other than yourself.

Neutrals

32 GRAYS AND TEMPERATURE

Colors, as mentioned on page 24, have temperatures: Hues that lean toward red, orange, or yellow are looked upon as warm, and hues that tend toward green, blue, or violet are considered cool.

Grays, too, can be warm or cool. Warm grays contain hints of red, orange, or yellow, and cool grays have a touch of blue, violet, or green.

Grays can also be labeled as something that a color cannot: temperature neutral. A temperature-neutral gray is precisely balanced between warm and cool and is without any indication of hue.

If you're an artist or a designer, it's a good idea to perpetually expand your awareness of the qualities, characteristics, and conveyances of different grays. The more you do this, the more you'll be personally able to dispel the myth that *gray* could ever be remotely synonymous with *boring* or *useless*.

You can fill beautiful illustrations, graphics, and patterns partly—or entirely—with gray-based hues: grays that are warm, grays that are cool, or grays that are a mix of warm and cool.

Warm and cool grays can also make excellent contrasting backdrops for bright accent hues. A warm and bright orange, for example, will seem downright fiery when used against a backdrop of cool gray(s), and a light and cool blue will appear perfectly frigid against a setting of warm gray(s). See page 92 for examples of gray-plus-color palettes.

COOL

NEUTRAL

WARM

82

Neutral grays

Cool grays

Warm grays

A combination of warm
and cool grays

33 WHAT IS BROWN, ANYWAY?

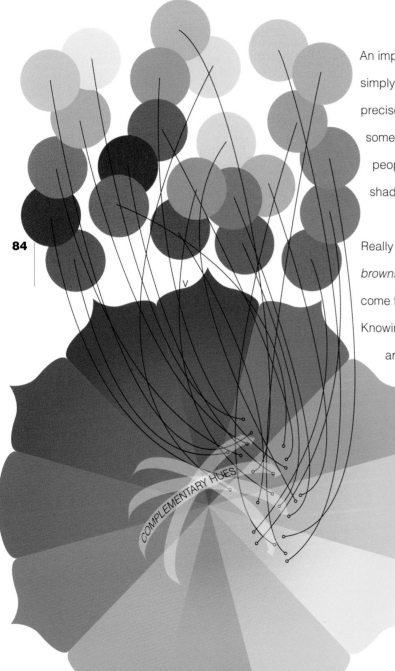

COMPLEMENTARY HUES

84

An important thing to know about *brown* is that it's simply a label—and an ambiguous one at that. A more precise and self-explanatory term for brown might be something like *muted orange* since the hues that most people think of as browns are actually deeply muted shades of orange, orange-red, or orange-yellow.

Really though, there's nothing wrong with calling browns *browns*—as long as you clearly understand that browns come from the same color wheel as any other hue. Knowing this—as opposed to thinking that browns are a separate species of animal than other hues—will make it easier to mix, choose, and apply browns to your layouts and illustrations.

Browns can be made by mixing a warm color with its complement. The exact shade of brown being created in this way depends on how much of each pigment is added to the blend and whether or not black and/or white are included.

Mixtures of triadic sets of colors can also produce browns. All browns that are created without black, in fact, contain at least a touch of all three primary colors (the primary triad, in other words).

Temperature-wise, browns commonwly tend toward the warmer side since most browns contain definite hints of the warmest spokes of the color wheel. Some browns, though, are cooler than others. For example, *walnut* browns—especially when seen near truly warm browns—convey noticeable hints of blue or violet.

You can build attractive illustrations and patterns from browns of similar or contrasting visual temperatures, and browns (including tints and shades that go by names such as buff, ivory, beige, earth tone, coffee, and chocolate)—like grays—can make terrific companions for both bright and semi-bright accent colors. (More about combining browns with colors on page 94.)

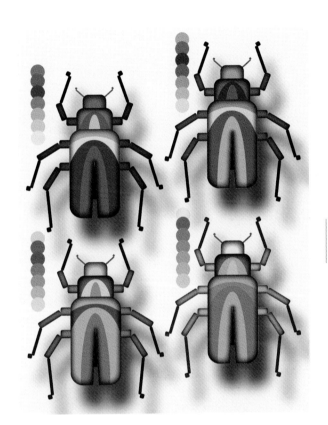

Each of these insects is colored with browns that are derived from the color of the specimen's head: red, orange, yellow-orange, and yellow. Adobe Illustrator's Color Picker panel was used to come up with each hue's family of related browns.

34 COMBINING NEUTRALS

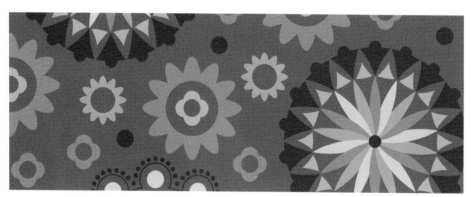

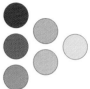

Mostly red-browns, with a yellow-brown accent color

Combinations of browns and/or warm and cool grays can be effectively employed as standalone palettes for images. They can also serve as ideal choices for backdrop hues and for the coloring of non-obtrusive background elements like patterns, textures, and illustrations.

An overall truth to finding strong combinations among browns and/or grays is this: Be decisive and aim for either *clear connections* or *obvious differences* between the palette's hues. Hints of an in-common color and/or communal conveyances of visual temperature are the sort of traits that can connect the members of a palette of either browns or grays. Conversely, obvious differences in color conveyances and/or visual temperatures can establish a healthy feeling of contrast among neutral hues.

The thing to avoid when combining neutrals is a look of indecisiveness: differences that aren't quite different enough—or similarities that aren't quite alike enough—to clearly let the viewer know that the combination of hues was intentionally and thoughtfully selected by a conscientious artist (as opposed to being randomly assembled by someone who may not have been paying close attention to their work).

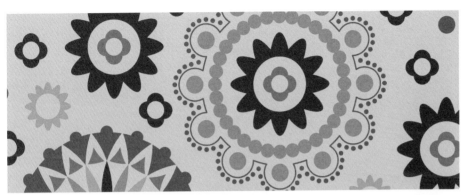

Cool grays with a dark warm gray and a light beige

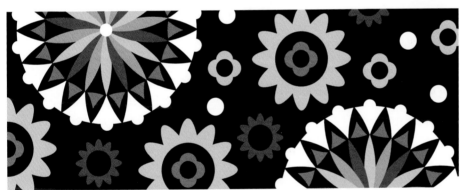

Black and white combined with browns of various personalities

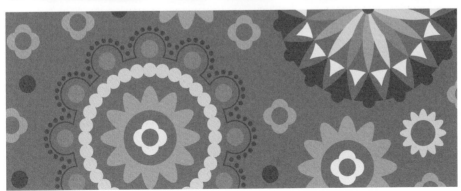

Dark greenish grays with red-tinted lighter grays

35 BROWN PLUS BLACK

Conventional wisdom says that wearing brown pants and black shoes is a fashion faux pas. And it may or may not be—depending on who's doing the wearing and whose doing the evaluating.

Whatever the case, know that in the visual arts there is no dictate against combining brown with black: It's all a matter of what browns you choose to pair with black, and why.

First, the why. Audience appreciation is one reason to consider letting black and brown share space on the same palette. An audience who favors rule-bending, quirky, and urban styles, for example, might be perfectly open to a palette that includes both leather brown and charcoal black (along with accents of, say, tutu pink and powder blue). Browns-plus-black can also make good sense when seeking connotations of art styles that embrace palettes of

this kind—the golden age of Japanese woodblock printing, for instance.

When seeking attractive combinations of browns and black, abide by the same two words of advice that were shared on the previous spread: *Be decisive*. Decisively choose to aim for either a feeling of strong connection or a sense of intentional opposition between black and any nearby brown(s). Browns that have a hint of black in their mixture stand a good chance of pairing well with black through a look of connectivity (browns made from a red-plus-black mixture fall easily into this category, as do light beiges and darker browns that appear close to the realm of warm grays). Browns that are decidedly oriented toward red, orange, or yellow can also be paired nicely with black by virtue of an appealing degree of contrast between these browns and black.

A pleasing sense of contrast exists between the yellowish browns in this illustration and its showing of black.

36 BLACKS

Blacks? As in, plural? Yes, indeed. Black comes in more than one flavor.

Black, like gray, can be warm, cool, or neutral. This is important to know whether you're an artist who uses paints, a designer who deals with printed media, or a person who does both. Most black paints and inks look similar to the eye when used at full strength and at full opacity, but when different kinds of black pigments are thinned (as in the case of paints) or printed at mid and light percentages (as with printing inks) the resulting grays will be either warm, cool, or neutral in temperature.

Artists who paint with acrylics are able to choose between carbon black, bone black, and mars black (among others): Carbon black is slightly cool, bone black is slightly warm, and mars black leans toward brown.

Designers and illustrators working with CMYK colors can warm or cool the appearance of the black and grays they include in their layouts and illustrations by adding percentages of color to their CMYK formulations. Five different process-color builds of black are featured on the facing page.

Photographers, too, use different films, different chemicals, different papers and different inkjet inks to produce images that include either warm, cool, or neutral blacks and grays.

Which temperature of black is right for the project you're working on? What does your art-sense tell you? Would a warm black—and its similarly warm grays— add a special note of style or era to your overall palette? What about a cool or a neutral black? Pay attention to the different kinds of blacks and grays you come across in works of design, art, and photography: Take note of the stylistic and visual effects produced by blacks and grays of different temperatures and keep your brain open to opportunities of using similar blacks for similar purposes.

Rich black is a term that applies to CMYK printing, and rich
blacks are created when more than just black ink is used
to create an area of black on a printed page. Below, four
examples of rich black are placed around a circle of simple
100% black ink. The differences are subtle (and you may need
to view the samples under good light and at a specific angle
in order to see these differences), but they may be significant
enough to warrant investigating for certain print projects. Be
aware that ink-alignment issues may arise
if you plan on reversing fine text or
linework from areas that are
printed with the multiple
colors that define a
rich black.

50%

50%

75c, 67m, 67y, 90k
Photoshop default rich black

70c, 0m, 0y, 100k
Cool rich black

0c, 0m, 0y, 100k

0c, 50m, 60y, 100k
Warm rich black

50c, 50m, 50y, 100k
Alternative rich black

50%

50%

37 COLORS WITH GRAYS

Once again, *be decisive:* The key to combining grays with colors is to emphatically aim for either visual agreement or intentional discord.

Employ warm and cool grays to create unobtrusive—and visually supportive—backdrops for text, graphics, and images that have been colored with attention-grabbing hues.

Also use grays to color an illustration's less critical components in intriguing ways while setting the stage nicely for the inclusion of brighter hues elsewhere in the image—as shown in all three of the illustrations on this spread.

Visual accord: The cool bright colors used in this illustration meld nicely with the cool grays used elsewhere in the composition.

Intentional discord 1: The warm colors at the center of this illustration stand in sharp and pleasing contrast against a surrounding palette of cool grays.

Intentional discord 2: Cool colors are applied to the central elements of this image—hues that intentionally set themselves apart from the warm grays that surround them.

38 COLORS WITH BROWNS

Browns can be beautifully paired with colors of all sorts. And why not? After all, browns—as mentioned earlier in this chapter—are themselves amalgamations of all colors and are therefore bound to have at least a little in common with any hue they associate with.

One thing to keep in mind when working with browns is that they can come from broad regions of the color wheel and as a result can exude a wide range of visual personalities. Browns can be muted, bright (relatively bright anyway), light, or dark. Browns can be somber, sassy, foreboding, and cheery. Browns can convey sensations of hot coffee, cold root beer, soft leather, hard earth, and sweet chocolate.

Take advantage of the wide range of visual and thematic traits that are available through different browns when choosing what browns to use in conjunction with what colors—simply be aware that it's generally advisable to aim for either strong inferences of connection or strong conveyances of contrast between browns and nearby colors.

Examples of effective brown-plus-color palettes are shown on the opposite page. Some succeed by virtue of in-common visual characteristics, and some thrive on account of intentional allowances of contrast between hue, saturation, and/or value.

While on the topic of browns, it's also worth mentioning that shades of brown—being so extremely diverse in appearance, mood, and conveyance—are particularly susceptible to the ever-changing whims of both public favoritism and popular scorn. Look at printed and online material from previous decades and you'll see how certain once-celebrated shades of brown are conspicuously absent from today's media.

94

Accord: A bright fuchsia sits comfortably among browns that share a similar color cast.

Intentional discord: A light cool blue stands in sharp contrast with its accompanying palette of dark warm gray-browns.

Accord: The bright yellow used here connects easily with the yellow hints emanating from a set of browns.

Intentional discord: A pale green sets itself clearly apart from the reddish tones of the neighboring browns in this sample.

39 PALE NEUTRALS

Pale neutrals are team players. Hues in this category
can be employed to beautifully set the tone (in terms
of both mood and aesthetics) for all kinds of works
of art and design without calling much attention
to themselves.

Pale neutrals (as well as very pale colors of any sort)
can do their quiet, theme-setting work when used
to color illustrations or borders, and they can also
perform their visual and thematic roles while being
used to fill backdrop elements for text and other
compositional components—as seen on this spread.

As mentioned throughout Chapter 12, Color and
Printing, beginning on page 192, it's important to use
printed guides when choosing CMYK colors. This is
especially true when selecting light colors that are
intended for use as backdrop hues: Most computer
monitors are notoriously lacking when it comes to
accurately portraying pale hues on-screen.

40 MUTED ALTERNATIVES

When using Photoshop to finalize a colorful illustration or a color photograph, it can be well worth the trouble of taking a quick detour from your normal workflow and seeing what might happen if some or all of its colors were muted. Muted a little, muted moderately, or muted a lot.

The results might surprise you. It's very possible that one of the muted versions will come across as more sophisticated, more contemporary, more attractive, and/or more emotionally charged than a fully bright version of the image.

Whether you settle on a muted version or a bright incarnation, it's easy enough to test: Open the image in Photoshop and start looking at options.

One convenient way of producing muted versions of an illustration or a photo—without actually altering the original image—is by opening the image in Photoshop and adding a Black and White adjustment layer. Use the adjustment layer's opacity setting to restrict the amount of color that shows through, and also see what happens when you use the pull-down menu and sliders available through the adjustment layer's control panel to further affect the image's appearance.

You can also use a Hue and Saturation adjustment layer to mute the colors within an illustration or a photo. This adjustment layer's control panel will allow you to lower the saturation of all (or some) of the image's hues through its pull-down menus and sliders.

Computers make visual exploration like this very easy and quick, so be sure to take advantage of modern technology every time you explore alternatives to the colors in a photograph or an illustration. Challenge yourself to look at a half-dozen, a dozen, or even more alternatives before deciding which solution looks most appealing (and be sure to save potentially usable versions of your image as you work). It's surprising how often the best solutions end up being ones that didn't reveal themselves until after a few extra clicks of the mouse.

Original photo

Saturation heavily reduced overall

Saturation reduced and yellow tint added

Saturation reduced and contrast heightened

100 CHAPTER 6

Interacting with the Eye

41 GUIDING WITH HUES

Value (as mentioned on page 34) plays critical roles in calling attention to key components of well-designed layouts. Good value structure also helps guide viewers' eyes through a layout's content once they've decided to look deeper into its full meaning and message.

It should go without saying that the colors in a layout or an illustration should also contribute to a layout's presentation of message and style.

Allowing hues to assist in this regard is not necessarily difficult as long the designer is working with the layout's goals in mind and is paying attention to the contribution each color's value and saturation are making toward these goals.

This graphic is colored with hues of mid-level brightness and calls less attention to itself than the brighter icon at the top of the page.

For example, a designer who wishes to bring attention to a headline could do so by establishing strong value contrast between the headline and its backdrop. The headline could be further emphasized by coloring it with an eye-catching hue and setting it against a backdrop of muted tones. The designer of the piece could then use hue, value, and saturation choices to guide viewers through sequentially less important—though hardly unimportant—elements of the composition by applying values and colors in ways that call for reduced levels of attention.

This graphic is able to add notes of decoration and creativity to the spread without calling too much attention to itself because of the lightness of its muted hues and also because it features limited differences in value. Being a lightly-colored design, it's also able to be used as a backdrop for text.

There's a good chance your eye went to this graphic first when you came to this spread. This graphic calls for attention not through its size or its placement but through its hues—hues that are notably brighter than any of the others on the page. Strong differences between the graphic's values also help it stand out.

Even the color of these callout containers has been chosen so that the callouts will *call out* for just the right amount of attention: Not too little, and not too much.

42 PUNCHING WITH COLOR

I f you really want to see an accent color punch its way to the forefront of attention, apply a heavy hand of restraint to all other nearby colors.

Done well, a color need not even be particularly light or bright in order to stand out if it's been surrounded by an effectively muted cast of supporting hues. The accent color featured on the opposite page, for example, is actually a fairly muted shade of yellow and would hardly seem remarkable if it were placed against a plain white backdrop (the same yellow was used to color the initial cap at the beginning of this text, by the way).

Unassuming and commonplace though it may be, the muted shade of yellow within this illustration promotes itself strongly when placed against a backdrop of dark cool grays and shadowy browns. The hue could be made to stand out even more if its level of saturation was increased.

43 BUILDING A CAST

Yet another way of looking at an effectively built and properly applied palette of hues involves comparing colors with actors.

When producers and casting agents want to fill a stage or a movie with actors, they usually end up looking for one or two starring personages, a small number of others to play supporting roles, and probably several more to fill scenes that call for extras.

Same goes choosing colors for a layout or an illustration: one or two stars, a few more supporting characters, and possibly others to act as filler that will fortify the look and the feel of the piece.

As you begin choosing and applying colors to your work of design or art, decide which components of the composition ought to benefit from the visual pull of a starring color (or, in some cases,

A cast of three browns and a dusty (but also relatively light and bright) red-orange exchange roles in the four identical layouts featured on this spread. Only the darkest brown and the red-orange are really capable of playing starring roles—the brown by virtue of having the darkest value and the red-orange by being the warmest and brightest of the colors.

Here, the dark brown is used to bring notice to the layout's largest type while also establishing a bold perimeter around the design. The red-orange—a hue that plays the role of accent color in the other three designs—is assigned the supporting task of providing a charismatic backdrop for this layout's trio of less expressive browns.

the visual pull of a small number of colors that work together as one). Also, decide what hues ought to be applied to secondary elements of the composition—whether textual, pictorial, illustrative, or decorative—and make sure the colors chosen for these less prominent roles hold back by virtue of their specific hue, value, and/or levels of saturation.

And once your colors have been put in place, evaluate what you see by asking yourself questions like, *Do the starring colors truly have center stage to themselves, or are other hues competing for attention? Are the supporting hues walking the fine line between attracting too much—and not enough—attention? What adjustments—if any—need to be made to turn this piece into a winning production?*

In this sample, the red-orange clearly asserts itself as the layout's attention-getter as it sits against the backdrop of a much darker brown. The darkest brown is used to bring secondary attention to the function of the piece—that of being a gift card.

And in this case the bird—a compositional element that has remained fairly unobtrusive in the previous designs—is given a visual boost through the application of the accent color. Which coloring is "right" for this layout? It all depends on the look, feel, and function you're aiming for. Explore your options thoroughly before deciding which roles ought to be played by which colors of any palette you apply.

44 COLOR AND DEPTH

The eye seems to enjoy interacting with two-dimensional media by being led on forays that appear to take place in three dimensions. Use the illusion of depth to draw viewers to all kinds of layouts and images that show themselves on either the level plane of a sheet of paper or the flat surface of a digital display.

What gives a three-dimensional rendering its feeling of depth? Optical perspective, for one thing. Optical perspective, in fact, can do its job perfectly well without any help from color, but color can usefully confirm and enhance projections of depth—while also adding bonus-items like thematic and aesthetic intrigue to an image.

Make value a priority when using color to enhance the illusion of perspective. In real life, it's the dark, medium, and light values of colors that inform our brains about the dimensional forms we see. Values serve the same dimension-describing function when they're applied within two-dimensional renderings.

If you're aiming for a reasonably convincing look of dimension through a graphic or an illustration, keep these painter-approved tips in mind: Objects that are meant to appear nearer the viewer should generally be depicted with a wider range of values than objects that are meant to look further away; the brightness of colors used within a scene should fade as they are applied to subjects that are more distant; and the effects of the prevailing atmosphere should have a greater and greater effect on the colors of objects as they appear further and further in the distance (a dusty outdoor environment, for example, will lend progressively more evidence of earthy and muted overtones to colors that appear increasingly distant).

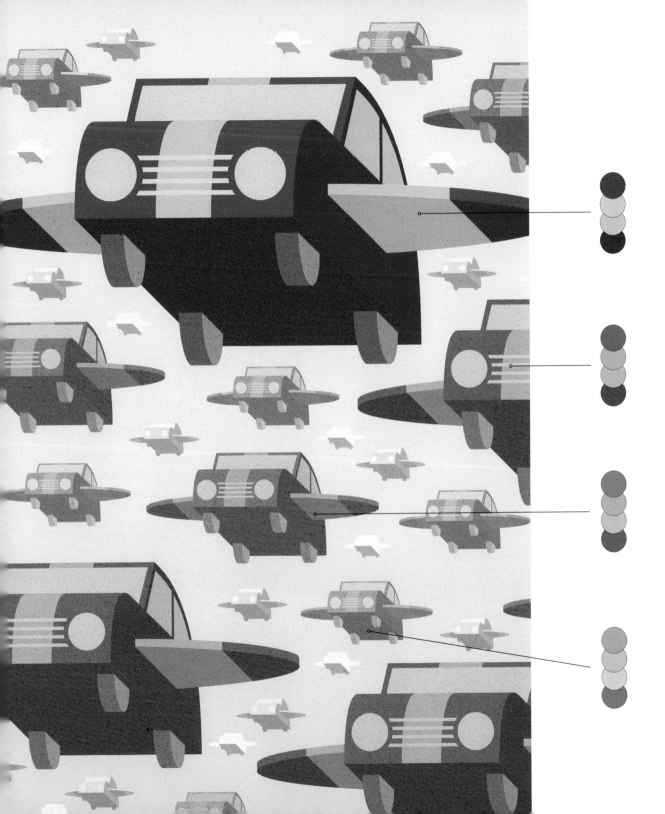

45 WHAT COLOR IS A SHADOW?

One thing to know about shadows is that they're rarely without light (and therefore rarely without color). The vast majority of the shadows we see are infused with a complex mixture of indirect light that has arrived to a shadow area after being reflected and bounced off a dizzying array of hue-altering surfaces.

Sound complex? It is. Very much so. And this is why the true color of a shadow can be a tough color to predict or to identify.

Warm light, cool shadows; cool light, warm shadows. That's what a painter might say when boiling things down for the portrayal of areas of a person, plant, animal, object, or scene that are not directly lit by the sun, a lightbulb, a flame, or any other source of illumination.

This is a good and versatile rule of thumb to keep in mind when determining how to depict the colors within shadows—but it's certainly not the only way to think about artistic depictions of areas that are not directly lit.

In fact, the coloring within a shadow—precisely because of its extremely complex nature—is exceptionally open to both visual interpretation and artistic representation. So much so, in fact, that a plausible depiction of a shadow might even be created by filling it with an abstract conglomeration of random hues. Don't believe it? Take a look at the illustration at right.

The moral of the story? Don't be intimidated when choosing hues to color shadow areas of an illustration. Try out the painterly warm versus cool advice mentioned earlier, try out the hue-darkening treatments covered on page 40, and by all means, if the project allows, experiment with solutions that have no connection whatsoever with reality-based depictions of shadows.

46 LETTING HUES BREATHE

Layouts and illustrations can—and very often should— be densely filled with sumptuous applications of color that deluge the eye with rich aesthetic wonders and penetrating thematic conveyances.

But remember, sometimes the most appealing and effective way of using color involves a far more limited approach—an approach that might even involve an ocean of white space.

47 COLOR AS BACKDROP

Most colored backdrops for layouts operate by the following principle of do and don't: *Do* boost the layout's thematic and stylistic conveyances; *don't* interfere with the layout's visual clarity.

Thematically speaking, a background color should work toward the same conveyances being sought by the rest of a layout's elements. When applying a background color, it's up to you, the designer, to decide what color will help convey the piece's message. Think on this and consider your options: There is usually at least a narrow range of colors that will work well for any project.

Not sure what background color(s) to consider? Check out the media enjoyed by your piece's target audience. What colors seem to be favored by this demographic? What colors are overused? What colors seem just right? (See Know Your Audience, page 152, for more about assessing the likes and the dislikes of potential viewers.)

On a purely practical level, it's very important to make sure the value and the saturation of a layout's backdrop color(s) help its starring elements stand out.

In most cases, this means choosing a background color that does not compete for attention with a layout's message-delivering components by being either too dark, too light, or too bright. If a background color is any of these things, then—unless you're intentionally trying to present elements in a visually challenging way for the purposes of thematic effect— you need to make adjustments to the layout's background color and/or the colors used in its foreground elements.

And don't rely entirely on your computer's monitor to tell you when changes need to be made (see The WYSIWYG Dream, page 178). Use accurate color charts and paper proofs to let you know how a layout's colors and components will look when printed.

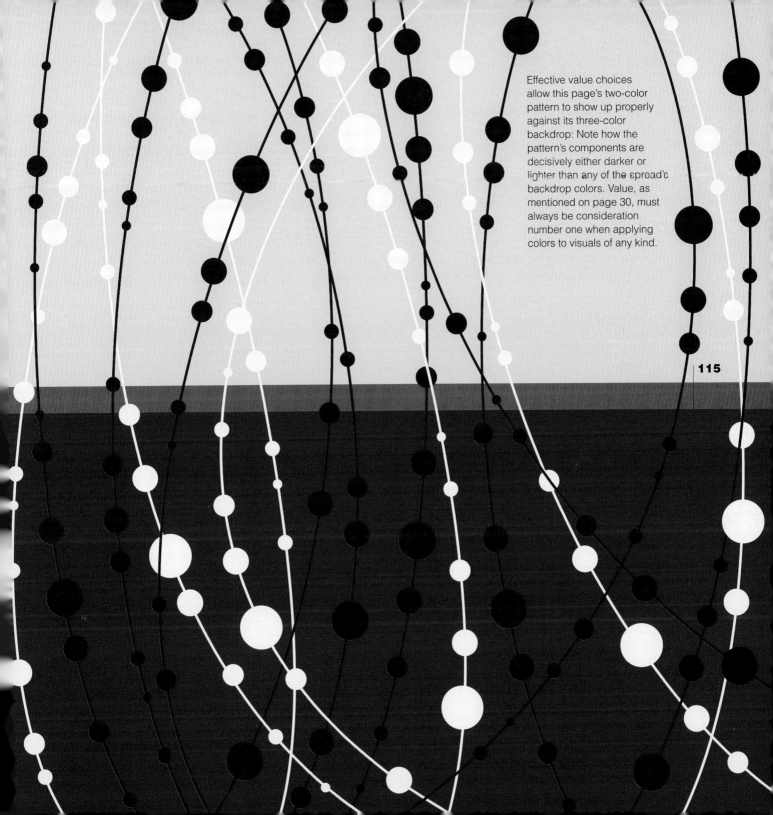

Effective value choices allow this page's two-color pattern to show up properly against its three-color backdrop: Note how the pattern's components are decisively either darker or lighter than any of the spread's backdrop colors. Value, as mentioned on page 30, must always be consideration number one when applying colors to visuals of any kind.

48 BACKGROUND HUES AS COMPONENTS

The role of a background color—as talked about on the previous spread—is usually to support and enhance the theme and the visual appearance of a layout or an illustration.

Sometimes, however, a background color itself can act as the central theme-delivering component of a work of design or art.

The next time you're brainstorming ideas for a project, sit back for a moment and ask yourself, *Is there some kind of direct color-connection that could be made with any of the themes I'm working with?* If yes, then maybe you can let one or more of your layout's colors do concept-carrying work that's normally handled by a headline or an illustration.

49 THE FORGIVING EYE

One last point about interacting with the eye before moving on to the next chapter.

Scientists describe the eye as a phenomenally complex and exacting organ that's capable of working with the brain to discern differences between ten million hues. In fact, brain scans have shown that data sent from the eye to the brain is so complex that fully half the human brain is involved in one way or another in the receiving and processing of visual information. And not only that, the eye is an exceptionally quick and agile little sensory organ: The muscles that control eye movement are more active and precise than any others in the human body.

Sounds like the eye is a pretty tough customer, doesn't it? Astonishingly perceptive, hard-wired to the most versatile computer on the planet, and extraordinarily athletic, the eye has got to be about the toughest-to-please client on earth.

But… it's not. Not at all. In fact, the eye is perpetually playful, endlessly willing to compromise, and abundantly forgiving when it comes to dealing with perceptions of color.

Take the snow-woman on the opposite page as a case in point. What color is her snow? It's certainly a long way from white. (Want to see just how far from white the snow-woman's body really is? Curl this page over so that the white of a previous page touches her mid-section and compare the almost-true-white of the paper with the nowhere-near-white of Ms. Snow-Woman's body.)

It's as though the eye sees the snow-woman and says, *It's okay if her snow is a light dusty beige, and that the scene's sky is a speckled tan, I know what is meant, and I accept it.*

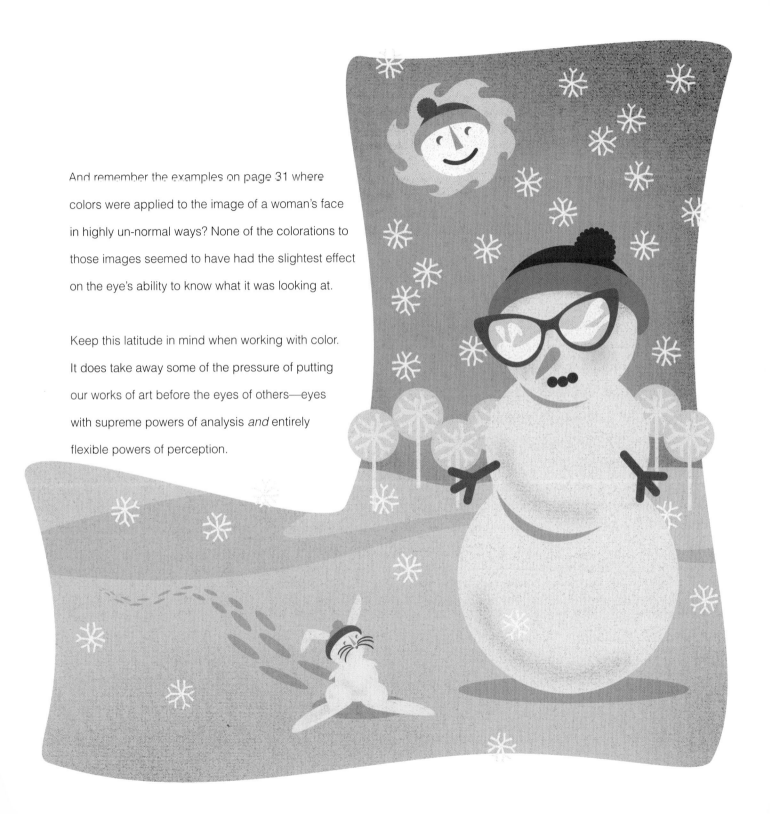

And remember the examples on page 31 where
colors were applied to the image of a woman's face
in highly un-normal ways? None of the colorations to
those images seemed to have had the slightest effect
on the eye's ability to know what it was looking at.

Keep this latitude in mind when working with color.
It does take away some of the pressure of putting
our works of art before the eyes of others—eyes
with supreme powers of analysis *and* entirely
flexible powers of perception.

CHAPTER 7

Illustrations, Graphics, and Photos

50 PLANNING AND APPLYING

Designers and illustrators have to make all kinds of important decisions concerning content, composition, style, and color when working on logos, layouts, and illustrations. Here's a suggestion: Whenever possible, establish your piece's look, structure, and feel using shades of gray before you begin applying color to your work of design or art.

Why follow this grays-before-color procedure? It's because there's often no point in applying hues until you have a good idea of exactly what you'll be coloring and how many hues you'll be needing to assemble for your palette.

Another good reason to work in the value-only mode of grays prior to applying color is that it will give your busy brain a break by allowing it to focus entirely on the intertwined aspects of content, structure, and style before being asked to turn its full attention to matters of color.

Illustrator can make this process easy: Once you've created your logo, layout, or illustration using grays, and once the value structure of your grays-only composition is looking good, you can then use commands available from within the program's Swatches panel to replace each of the grays with colors of your choosing—colors that have the same values as the grays they replace.

You could also follow this approach when painting by creating a preliminary version of your piece using only shades of gray, and then gradually covering the grays with colors as you work toward finish (artists who use traditional media have employed this method of painting for centuries, and you can also apply it when working digitally).

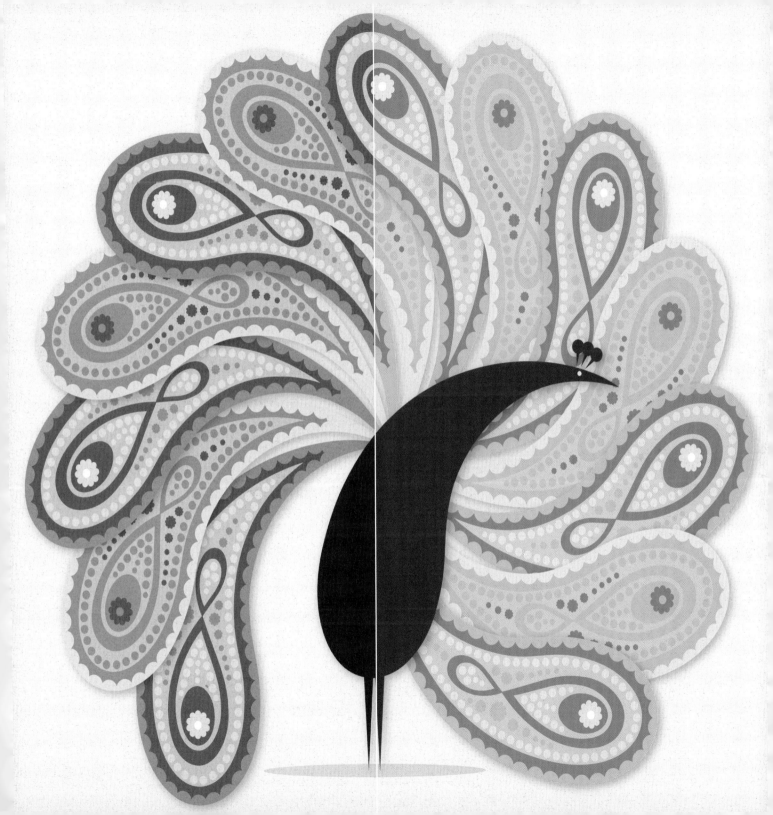

51 ENHANCING VALUE DISTINCTIONS

The hues of your layout or illustration will have no trouble standing out against each other if their values are notably different where the colors meet.

There are times, however, when you'll find yourself wanting (or needing) to place similarly valued colors next to each other for stylistic reasons—or maybe when you're prescribed to do so by something like a client's corporate standards manual that requires that certain colors be used together.

What to do in situations like these? For one thing, you could incorporate linework within your layout or illustration to establish clear boundaries between colors of similar value (more about this on the next spread).

Another thing you could do is adopt a stylistic approach that adds convenient notes of darkness and/or lightness to color boundaries where value concerns arise. Four such techniques are demonstrated on the opposite page.

Keep your eyes open for examples of how designers and illustrators have effectively handled situations where value distinctions between hues could have been problematic: You never know when you might need to call upon solutions of this kind for real-world projects.

This illustration's content is difficult to make out simply because its various hues are similar in value. You could remedy the confusing and unattractive look of this image by finding ways of adding notes of either darkness or lightness along the boundaries between colors—as demonstrated in the examples at right.

124

Drop shadows

Hints of darkness

125

Hints of lightness

Hints of both darkness and lightness

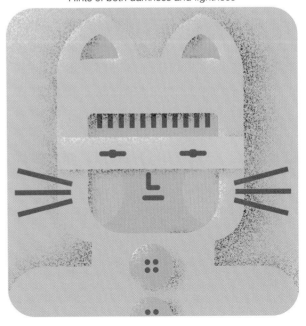

52 LINEWORK BETWEEN COLORS

You can add linework to icons and illustrations for stylistic purposes. You can also employ it to alleviate value-structure issues when using hues of similar values.

Consider your options when adding lines to images.

126

Lines can be thin, thick, smooth, sharp, blurred, rough, curvy, linear, dotted, dashed, black, white, gray, or colored.

InDesign, Illustrator, and Photoshop offer many different linework options, and the Brushes panel in Illustrator and Photoshop features a vast array of stylistic choices that you can apply to linework to mimic the look of lines drawn with pencils, pens, brushes, and patterns.

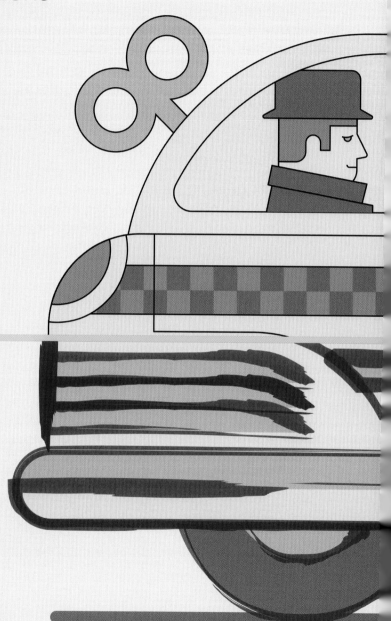

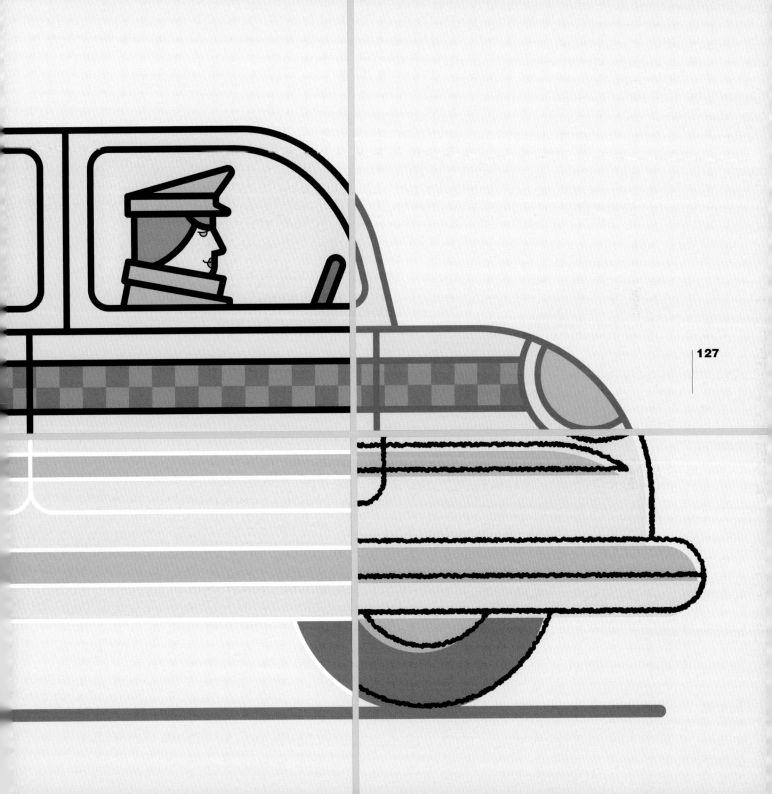

53 PHOTOGRAPHIC PALETTES

Original image

Think of the colors appearing within the photos you shoot in the same way you think of the hues you apply to the illustrations you create—as being both individually and globally adjustable.

When assessing the look of a photo's colors, ask yourself, *Do the hues in this image work well together, or do I need to make adjustments to help them visually gel? Should I make either minor or drastic changes to the photo's hues, the intensity of its colors, or the strength of its values? Is there one particular hue that needs extra attention?*

Your decision to make adjustments to a photo's palette may be motivated by stylistic preferences, or it may be driven by practical concerns like making sure an image's colors connect well with a layout's overall palette or ensuring that its content shows up clearly.

Whatever the case, the lesson here is this: Never take a photograph's colors for granted. Work with the diligence of a painter to fine-tune your images' colors until they meet your stylistic, aesthetic, and practical goals.

54 TINTING MONOCHROMATIC IMAGES

Back in the days when black-and-white and sepia-toned images were the only choices available to photographers, printmakers devised an image-enhancing technique where colored transparent inks could be painted over the top of monochromatic photos to produce semi-realistic—and inherently stylized—pictures of reality.

The look of these images resonates well with many viewers, especially when they are seen in context with themes of nostalgia or bygone days. And while this look is not often required for works of commercial art, it's still worth knowing that you can create images of this sort with simple Photoshop tools and treatments should the need or the desire arise.

Painted layer

Black-and-white adjustment layer

Original photograph

Open your image in Photoshop and convert it to black and white using a Black & White adjustment layer. Experiment with different settings for the adjustment layer until you find a conversion that leaves a fair amount of mid and light values in the image. After that, add a blank layer over the Black & White adjustment layer and set the new layer's blend mode to Multiply. Next, use the Paintbrush or Airbrush tool to add colors to this upper layer—keeping in mind that the colors you apply will show up best when they are applied over medium and lighter value areas of the underlying image (this is because the top layer's Multiply blend mode setting causes its colors to show up in the manner of transparent inks).

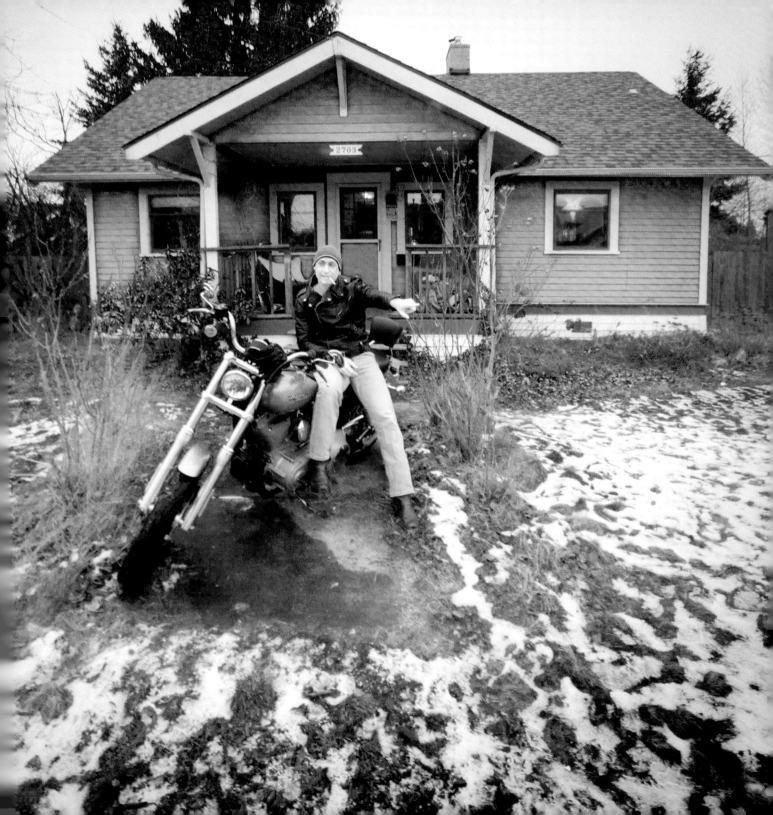

55 CONSIDERING WHITES

As those familiar with photographic terms may already know, white balance is achieved when a camera is able to record a shot that allows the whites in a scene to appear truly white—without strong hints of either warm or cool hues.

Aiming for technical perfection in terms of the white balance within a photograph or an illustration is sometimes called for—as when creating an image that's meant to portray the look of a product with as much color-accuracy as possible—but most times, photographers and illustrators handle the notion of white with a great deal of flexibility in the interest of delivering conveyances of atmosphere and mood (see The Forgiving Eye, page 118).

Think twice before accepting or applying pure and true incarnations of white in any photograph or illustration you're working with. Why? Several reasons. For one thing, absolute occurrences of true white rarely occur in the real-world scenes our eyes observe. Also, because opportunities to deliver connotations of time of day, air quality, light sources, mood, and emotion can be lost if an image's white balance is restricted to the straight-and-narrow of theoretical perfection.

And, while on the subject of white balance, how about messing with your camera's white balance settings the next time you're taking pictures of a person, place, or thing? (Most digital cameras offer auto white balance settings that are designed to compensate for various naturally occurring and man-made sources of light.) Try telling your camera that you're shooting under cloudy skies, for instance, when you're actually taking pictures under an incandescent bulb. You might be pleasantly surprised by the results.

56 A TOUCH OF TEXTURE

Color lends thematic inferences to visuals of all sorts—illustrations and photographs included.

It's worth mentioning, too, that texture, when it's added to a color illustration or photo, can further amplify or alter the conceptual implications that arise. You could use a parchment-like texture, for example, to strengthen the connotations of luxury emanating from an illustration's ivory-colored backdrop, or you could employ a roughly crackled texture to lend notes of distress or aging to the otherwise perky-looking hues of a photograph.

Photoshop and Illustrator make it easy to add texture-infusing layers to photos and illustrations. You can put images of everyday textures like those evident in a cracked concrete slab, the peeling paint of an old sign, or a plush piece of fabric on layers over the top of a photo or an illustration, and then adjust the blend mode and opacity settings of the textural layer until your sought-after effect is achieved. (Be sure to experiment with these settings—their results can be difficult to predict, and for most designers, it's just a matter of trying out different options until you find what looks best.)

Make a point of keeping a pocket digital camera on hand as often as possible so you can snap photos of visual texture whenever and wherever you come across them. Having a well-stocked folder of images like these on your hard drive will give you all kinds of options to consider at a moment's notice when you're looking to add touches of texture to photos and illustrations—as well to logos and layouts.

134

Textural layer added with blend mode set to Overlay, and its opacity at 100%

Textural layer added with blend mode set to Screen, and its opacity at 75%

Textural layer added with blend mode set to Multiply, and its opacity at 80%

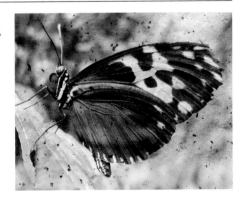

57 EXPLORING VARIATIONS

So, you're finally satisfied with the look of the colors in your logo, layout, illustration, or photograph. That's terrific. Time to move on.

But wait a second. How do you *really* know your palette is showing itself in its best possible way? Have you tried out at least a few options to make sure there's not a better solution out there, just waiting to be found? If not, how about opening a copy of your document and exploring some minor— or major—alternatives in the way your colors have been applied?

For example, what about shuffling the colors in your logo, layout, or illustration so that its colors appear in different places? And how about increasing the intensity of your palette's brightest hue(s)? Would it help to mute your piece's more restrained colors a bit more than they already are? Could you replace any of your hues with less obvious choices (like changing the color of the sky in an illustration, for example, to something like a dull green or a dusty rose)? What about applying global changes of the sort described on page 186?

Palette-modifying exploration of this kind is usually very easy when working digitally, and it's also a low-pressure creative endeavor, since it's always done with the knowledge that you already have a perfectly satisfactory solution waiting for you if none of your alternative solutions look better than what you started out with.

138 | CHAPTER 8

Conveyances

58 COLOR AND CONNECTION

Colors convey.

Engage your creative instinct at its keenest and most perceptive level whenever working with hues: Be mindful—and take full advantage—of color's intrinsic ability to connect with viewers on deep conceptual, emotional, and energetic levels.

olor
veys

59 COLOR AND MEANING

The likes and dislikes of humans are far too complicated to assess through generalizations like, *people love pepperoni pizza, people think sun is better than rain,* or *people are attracted to green because it represents health, well-being, and vitality.*

The only problem with lending credence to assumptions like these is that they are very often misleading, irrelevant, or flat-out wrong.

This is pointedly true when talking about the supposedly specific meanings generated by colors. Yes, it's true that a rich shade of green, for example, could deliver inferences of health, well-being, and vitality when applied to an illustration of something like a fresh head of broccoli. But what if the very same green was applied to a rendering of a moldy piece of bread? How would the green convey itself in that case? Very differently, wouldn't you say?

Context, in other words, is far more important to a color's delivery of meaning than the specifics of its hue, saturation, and value.

And context is not the only powerful modifier of the inferences that arise from colors. Current trends, historically held traditions, and cultural influences (talked about on the next spread) also play major roles in affecting the conceptual notions brought about by the appearance of certain colors.

143

60 COLOR AND CULTURE

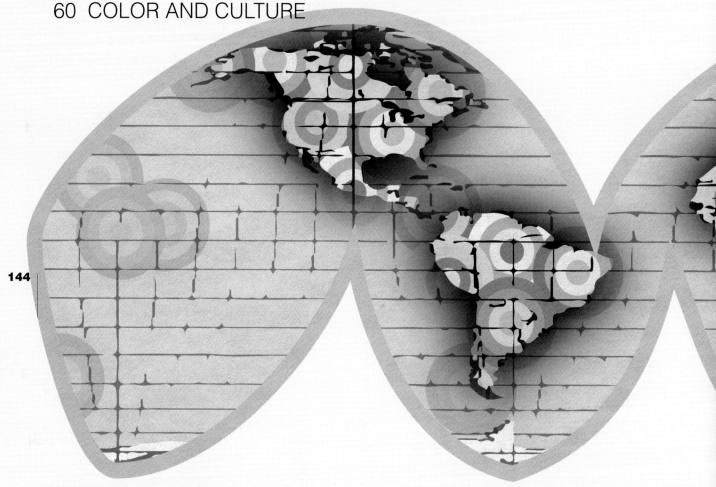

In China, red is seen as the color of success. North Americans refer to green as the color of jealousy. Native Americans see black as the color of balance. South Americans consider purple the color of mourning. Japanese people deem white to be the color of respect. Muslim cultures think of gray as the color of peace. Africans believe blue is the color of love.

Are these statements true? If so, are they true to a small, medium, or large percentage of the people who belong to the particular country, culture, region, or religion being talked about? And, most importantly, are these statements seen as true and relevant to the specific audience you're targeting with your work of design or art?

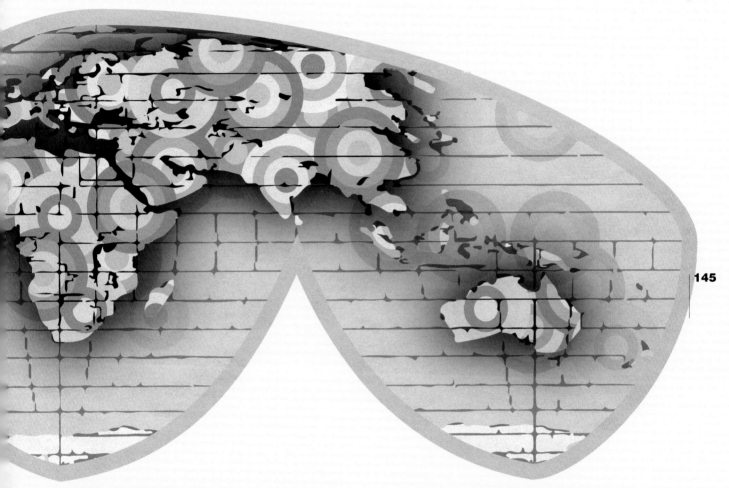

Best to find out before going too far with the application of color to any logo, layout, or illustration that's aimed at a demographic other than one with which you're deeply familiar. To do this, you may need to get in touch with some actual representatives of your target audience and/or consult well-researched printed and posted material.

In any case, the last thing you should do when choosing colors for a demographic that's unfamiliar to you is assume that any preconceived notions you may hold about this demographic's tastes in color are in any way connected with reality. Three words of advice: Research, research, research.

61 INTENTIONAL NONSENSE

Sometimes, using color in a *wrong* way can be a perfectly *right* way of delivering a layout's stylistic and thematic flavor.

Remember this when you're aiming to convey a message or an idea through a punky, quirky, or capricious visual delivery—a delivery that may or may not be echoed and emphasized by the look of other components of the logo, layout, or image of which they are a part.

146

62 FUELING INTUITION

It takes color-theory know-how and creative intuition to come up with aesthetically pleasing palettes that are accurately aimed at their target audience. But what stokes this kind of knowledge and instinct? It takes fuel, of course—fuel that's formulated through a blend of learning and experience.

Take the time to learn about color through the readily available and easily accessed media of books and websites.

Learn too, directly from people who practice art at a competent level—coworkers, teachers, art-minded friends, and the like. This kind of learning could take place on an informal level (asking another designer to explain the thinking behind their selection of colors for a layout, for example) or within the more structured environs of a classroom or a workshop.

And, very importantly, seek and study the historical works of great designers, illustrators, and fine artists.

Take a close look at how these individuals have used color, and try your best to understand the thinking that went into the selection and application of the colors they've applied to their works of design, illustration, and fine art.

And by all means, seek real-world opportunities to practice what you know about color: Experience is every bit the masterful teacher it's reputed to be when it comes to any aspect of creative expression. If your on-the-job work is not providing you with the right kind of environment to expand your knowledge of color, then make a point of coming up with personal design and art projects that will present you with the learning opportunities you're looking for.

Make a regular practice of doing all these things, and both your intellectual understanding of color and your intuitive feel for how color can be applied to works of design and art will never cease to develop and grow.

150 | CHAPTER 9

Corporate Color

63 KNOWING YOUR AUDIENCE

Some designers, and even more clients, completely miss this ultra-important point: It's not a matter of coming up with a palette that pleases either the designer or the client, but rather a matter of attracting and engaging a targeted audience through effectively chosen colors that have been applied to well-crafted logos, layouts, and illustrations.

Yes, it really is *all* about the target audience when it comes to choosing palettes for works of commercial art. And never forget, design is nearly always a commercial art.

If you have been a designer for any length of time, and have met regularly with clients, then you probably know that some are simply unaware that their own aesthetic preferences need to take a backseat to the preferences of their target audience.

Educate your client on this point, if necessary, and do so with maximum levels of tact, clarity, and urgency. After all, you will have a much easier time working with a client who is evaluating your layouts and illustrations according to the same criteria you're using to create them—and both you and your client will benefit from any aesthetic approach (those involving color, content, style, and more) that effectively attracts and engages the people your client is trying to reach.

How do you get to know your target audience? Here are the steps: Find out who they are (ask for your client's help here); study the media this audience looks at; take notes and/or save images that describe the colors, content, and styles your audience seems to prefer; and also consider meeting and talking with members of your targeted demographic (not a bad idea if you really want to gain some insights into the way these people evaluate media that's aimed at them). Retain any notes and images you come up with during this investigative process: This material might prove invaluable as supporting evidence if you're asked to explain the rationale behind the colors, content, or styles that manifest themselves in your creations.

64 EVALUATING COMPETITION

Whenever you develop palettes for a client's branding or promotional material, aim for color schemes that will not only appeal to your piece's target audience, but will also be seen as being clearly different—and hopefully better looking—than anything in use by competing firms or organizations.

154

Give yourself some help with this task by asking your client—during the very earliest stages of a project—who their competition is. Get a list of names and look them up online before you even start considering individual colors or full palettes for whatever it is you're working on.

Research this matter on a local, national, and (if necessary) international level. Carefully investigate the branding practices of your client's competition so you can avoid the embarrassing and/or disastrous fallout that might occur if you were to inadvertently choose colors that are similar—or plainly inferior—to those being used by one of your client's competitors.

Be thorough, sharp-eyed, and critical when assessing potentially competing colors and color schemes. Take note of both the specific hues and complete palettes that you find in competitors' logos, advertisements, promotional material, products, websites, signage, and vehicle graphics. Also, make an effort to learn from both the strengths and the weaknesses you detect in the way competing firms and organizations have used color to present themselves to the world.

Once you've taken a good look at the way your clients' competition employs color for their branding and promotional pieces, aim for gaps in what you see: Select colors that are notably different than anything already in use, and also seek fresh and unique visual strategies for applying your chosen palette to the work of design or illustration you're working on.

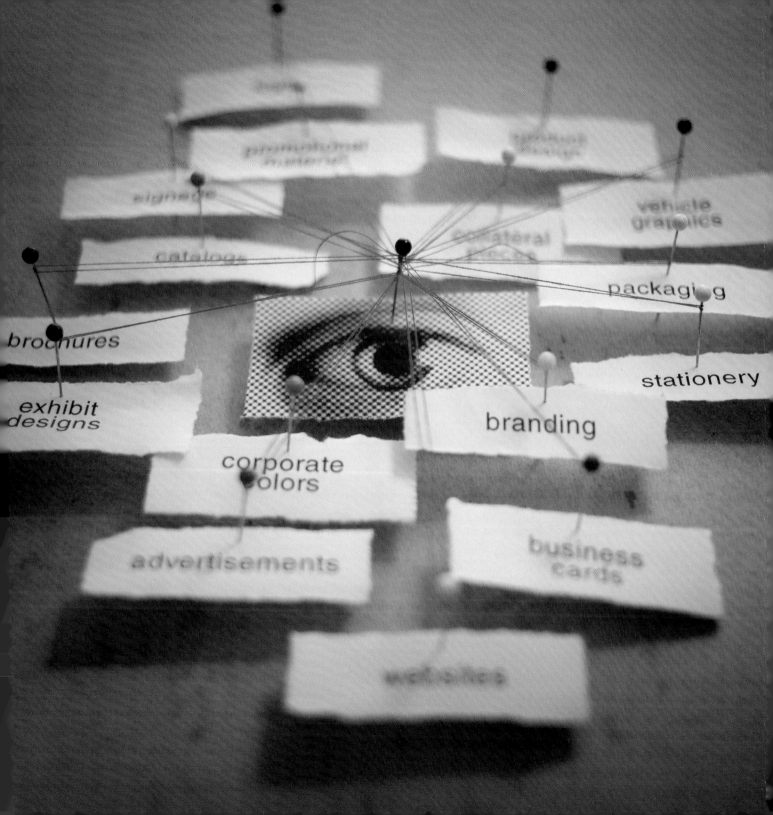

65 PRACTICAL CONCERNS

Coming up with a good-looking palette that appeals to your client's target audience can be a challenge. Add to this task the feat of choosing colors that will stand out against any competing works of design and the challenge increases. And, if all that weren't enough, there is still a handful of purely practical considerations to be managed with skill and discernment by any designer who is developing a palette for the branding and promotion of any company or organization.

For example, you need to take shelf life into account. Meaning, you will need to come up with a palette that will stand a good chance of looking fresh and relevant for a reasonable length of time within the ever-changing context of today's media.

How long should a corporate color scheme be expected to remain sightly and pertinent? This largely depends on the nature of the company or organization being represented. If you're working for a firm that deals with relatively unchanging and long-term practices, such as law, finances, or real estate, then the colors used to represent your client should probably be among those that are themselves seen as reasonably impervious to the winds of change—standard shades of deep blue, burgundy, or gray, for example.

If, on the other hand, your client deals with products or services that are linked to rapidly evolving trends in fields such as fashion, music, sports, or technology, then colors of a more evanescent or transitional nature might

156

Other practical concerns involving corporate colors include obvious (but also surprisingly easy-to-overlook) issues like whether a sign's colors will allow it to show up properly against its backdrop; whether the palette being used for a vehicle's graphics will cause confusion by being too similar to the colorings of local taxi, ambulance, or delivery services; and whether the color scheme you're applying to a menu design will look good amongst the decor in which it will naturally reside.

be permissible—specific and timely shades of lipstick fuchsia, hipster brown, or neon green, for example. Colors such as these, due to their inherently time-sensitive dispositions, will likely need to be adjusted or replaced every few years in order to remain attractive in the eyes of their target audience, whereas colors of a more fad-resistant nature (like the standard shades of blue, burgundy, or gray mentioned earlier) might remain viable for decades before needing reassessment.

66 ASSESSING TRENDS

Throughout this book, the suggestion has been made that you keep a sharp eye on the work of great designers and illustrators through annuals, websites, magazines, and books. Clearly, this is a habit that's necessary in order to develop and maintain the ability to choose colors that are in step with the popular preferences of today.

Another benefit of this practice is that, over time, a designer who has been paying continual attention to color trends will also develop a natural cognizance of the inevitable cycles that occur within this facet of popular favoritism—cycles where certain fashionable colors are on the rise while the popularity of others are fading; where some hues and palettes are returning after a long time gone and others are going down like burning meteors into the abyss of permanent oblivion.

Make a point, then, of really paying attention to what is—and what has been—going on in the realm of color so you can develop an awareness of both current and past trends—an awareness that should go a long way in helping you understand and predict (with at least a fair degree of accuracy) trends that have yet to occur.

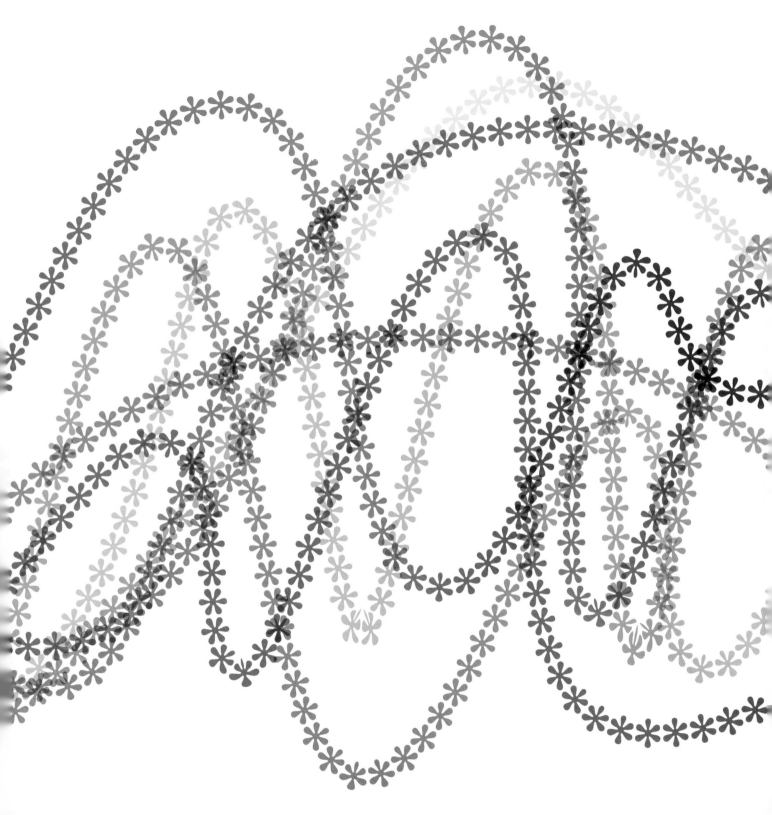

67 SELLING IT

You've just finished a layout for your client and have applied what you feel is an exciting, engaging, and timely color scheme to your design—a palette built around an eye-catching shade of periwinkle blue. Why this blue? It's because you believe your target audience will find the hue highly attractive, and also because none of your client's competitors are using a color that's anything like it for their promotional material. Now it's time to present your layout to the client's design committee—a group of individuals with a diverse set of tastes and a wide variety of temperaments.

Setting aside momentarily the fact that, in the real world, the committee members would be evaluating all aspects of the layout you're presenting—including its content, composition, and stylistic flair—we'll concentrate here mainly on the color-related aspects of your engagement with those who'll be reviewing your work. Here's some advice.

First of all, enter the conference room with the full confidence that you have indeed developed your layout's palette based on a careful evaluation of the tastes of the target audience (page 152), an analysis of the colors being used by competitors (page 154), and according to your awareness of larger-scale trends in color (as talked about on the previous spread).

Next, begin the proceedings by diplomatically reminding the committee members that it's not necessarily their tastes that you will be trying to satisfy with your layout. Rather, it's the tastes of the target audience. Then, briefly summarize who that audience is and what their preferences are. This will not only remind the various participants of the project's aims, it will also help everyone get in sync with an in-common way of evaluating what they'll be looking at.

Now present your work and simply let people look it over. Don't bombard committee members with the rationale behind your color choices unless asked to do so: Effective works of design and art are usually capable of speaking for themselves—colors and all.

Once the committee members have had a good look at your design, feedback is sure to arise with little or no prompting from you, so just let things happen naturally. Listen patiently and carefully to any questions and comments that come up, and address each as thoroughly and frankly as possible. Resist the temptation to roll your eyes if, for instance, someone remarks that they don't like the periwinkle blue because it reminds them of the brightly painted minivan they inherited from their parents in high school. Simply laugh with that person, paraphrase their words so that they can be sure they've been heard (a useful communication technique taught in many books about getting along with others), and then let the commenter know that even though you regret that they had to be seen in that particular minivan in high school, the periwinkle blue you've applied to the layout remains an excellent choice for this project due to the appeal it should have among the layout's target audience.

Also, unless you feel extremely confident that you're presenting the client with *the* one-and-only perfect color scheme for their layout, you may want to bring two or three alternative color ideas to the meeting as well and keep them stored on your laptop or tablet in the event that you decide to share them with the group.

CHAPTER 10

Inspiration
and
Education

68 SEEING COLOR

As truly amazing as our brains are, they simply can't notice everything around us at all times. We'd probably experience the human equivalent of a serious system error if our brains tried to visually and mentally assess even a fraction of the things—and the details within those things—that pass through our field of vision during even one minute of a day.

That being the case, if you really want to start noticing, and learning from, attractive instances of color in the world around you—as designers and artists would be wise to do—it'd be a good idea to let your brain know that it has your permission to devote the time and head-space needed for these practices.

Encouraging your brain to increase the amount of attention it pays to colors and palettes is relatively easy to do, and you'll find that providing it with a touch of motivation and prompting can help. In fact, you've probably already done something similar in other areas of your life and benefited from the results. Remember, for instance, the last time you decided to shop for a car? Remember how, at that time, all of a sudden, your eyes and brain started noticing a surprising number of cars just like—and very similar to—the type you were intent on buying? It's not that the kind of car you were looking for was suddenly any more common than it ever was. It's just that your brain had been given a good reason to look for it and permission to bring its presence to the fore of your attention.

Try it with color. Assure your brain that there are plenty of good reasons to pay attention to colors, and ask it to devote more attention to this aspect of the visual world. And while you're at it, be sure to let your brain know that you're open to finding intriguing and appealing instances of color whether your eyes happen to be aimed at a design annual, a work of art, a movie screen, a cityscape, a landscape, the evening sky, a bed of flowers, a pile of rocks, a child's toy, or absolutely anything else that might offer a moment of color-related inspiration and learning.

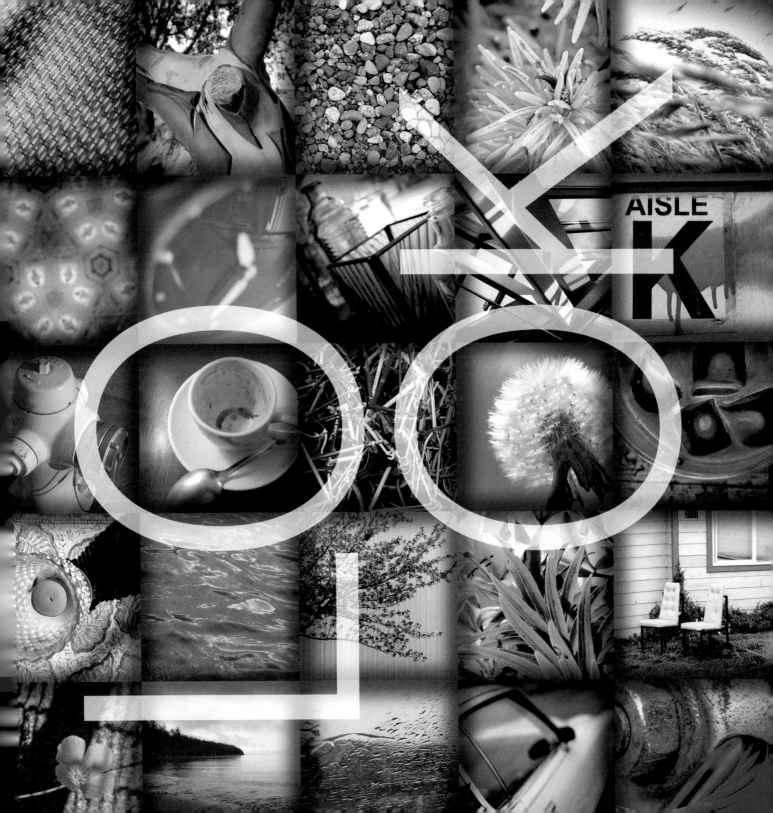

69 LOOK. EVALUATE. TAKE A PICTURE.

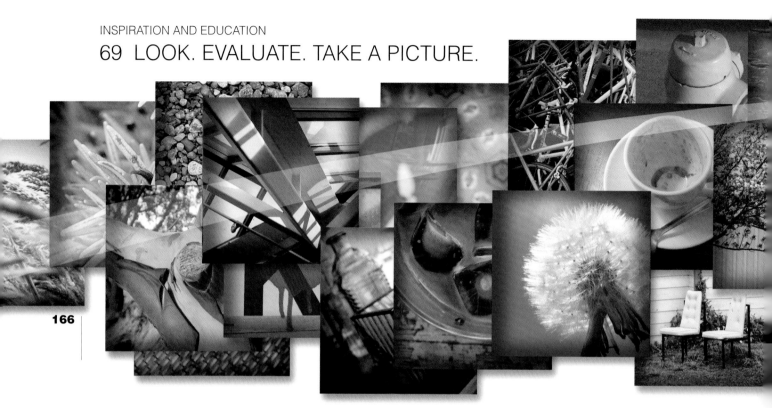

Whenever possible, take a moment and try to figure out just what it is that makes certain palettes appeal to your eyes—whether the color scheme appears to have been created by a person, through a happenstance occurrence, or as the result of a naturally occurring event.

Ask yourself, *Are some or all of the colors in this palette organized according to any of the color-wheel–based associations described in Chapter 3, or are they pretty much all over the place? How many different hues are there in this color scheme? Are the hues consistently bright, muted, light, or dark—or are their qualities of saturation and value varied? Does this palette have something in common with other color schemes I seem to favor? Am I working on a project right now where I might be able to use a palette like this? What about future projects?*

color
ideas

This mental exercise could also be turned on its head when you come across examples of poor color usage. Try spending at least a minute or two figuring out what it is that's not working when you see examples of ineffective or misleading applications of color. This can be a very useful practice since it gives us the opportunity to learn important lessons about color without having to suffer the consequences of having made certain mistakes ourselves.

Help your brain remember what it's learned about attractive palettes by snapping photos of what you come across. Create a folder on your hard drive where you save pictures of appealing color schemes for future reference and as idea-sparking visuals that you can refer to when developing palettes for logos, layouts, illustrations, and works of fine art.

70 BORROWING INSPIRATION

First of all, what does it mean to *borrow inspiration* as it's being talked about here?

Simple: It means looking at art created by others, and allowing what you see to mix with your aesthetic and stylistic preferences in order to come up with color schemes that you can legitimately call your own. Borrowing inspiration is what artists have done since the earliest days of visual expression. It's what creative individuals do to learn from, build upon, and sometimes echo that which has been done before.

Borrowing inspiration is not the same as *stealing ideas*. One is okay. The other is not.

Borrowing inspiration *could* involve a certain degree of copying, as when you copy the colors from one of your personal photographs for use in layout, or when matching certain colors from a historic work of art (a beautiful range of sunflower yellows, for example, from one of Van Gogh's paintings) and applying them to a piece of your own.

This form of inspiration gathering could be extended to include times when you match a color from a piece of design, art, interior decoration, or signage and use that hue as a seed color (see Seeding Multicolor Palettes, page 72) for your own custom-built color scheme, or when matching, for instance, the faded and yellowed colors from a 1960s travel advertisement for use in an intentionally retro-looking poster design.

71 HISTORICAL AWARENESS

As mentioned on the previous spread, art is perpetually affected by that which has been done before. In many cases, art of one era builds upon earlier creative efforts. And other times, individuals rebel against the work of their predecessors in order to bring about major transformations in the art scene.

170

It shouldn't be surprising, then, that the most influential and innovative leaders in design and art are very often those who have the clearest grasp on historical expressions of their craft. Makes sense, when you think about it, since it's very difficult to either embrace or reject the creations of earlier artists without a sharp awareness of their work.

How about you? How much attention have you given to design and art from the near and distant past, and how much time have you spent familiarizing yourself with the ways in which color has been used by the creative giants of yesteryear?

If your answer is along the lines of *not too much,* then you don't know what you're missing (both figuratively and literally).

So how about it? What about going to the library, the bookstore, or online and checking out the works of great artists and designers of earlier times? Not only will this archival material confirm much that you already know about aesthetic and communicative principles, it will also fill your mind with approaches, ideas, and imagery that can be transformed into the logos, layouts, and illustrations you're asked to create in the future.

72 PERCEPTION PROBLEMS

Artists who paint from real life know this all too well: The colors you think you see are rarely the colors you are actually seeing.

The brain—through the best of intentions—very often tries to inform us of the supposed colors of familiar things based on a massive data bank it keeps on the subject: *stop signs are red, sky is blue, sunflowers are yellow,* and so on.

172

Artists have the distinction of being among the few types of people who are legitimately hindered by this well-intentioned talent of the brain. Many an artist can attest to the amount of time and experience that's gone into learning how to *tune out* the brain's sometimes adamant advice regarding the colors of familiar things so they can see hues as they actually are when creating works of art based on real-life subjects and scenes.

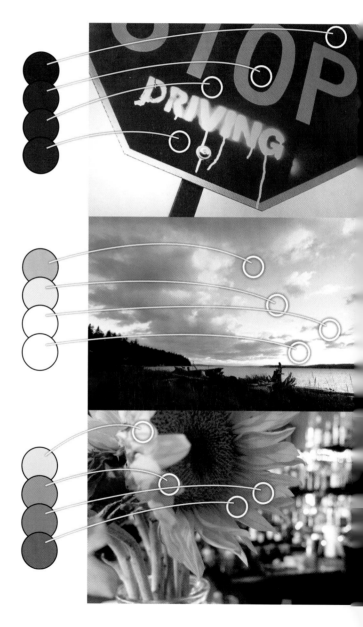

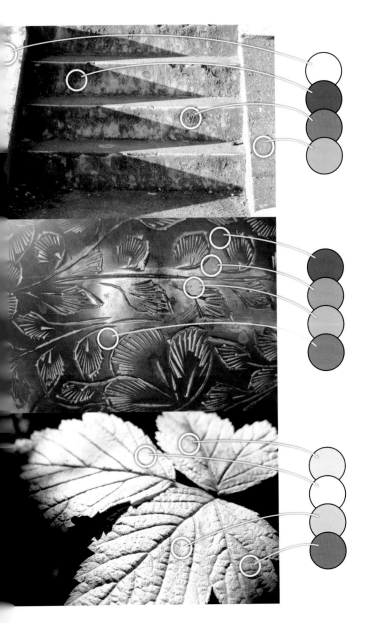

Two things are key in teaching your eye to see colors for what they are—should you decide this is important to you as an artist or a designer. The first is to understand that what your brain tells you about color can be misleading, not only because of the preconceived notions it holds, but also due to perception-complicating factors like varied sources of light, the presence of shadow areas, and impurities in the ambient atmosphere. And second is that you give your eye and brain the chance to recalibrate their color sense through practice—and there are few (if any) better ways of refining your ability to see colors accurately than by learning to paint from life. (See Chapter 13, Paint? Paint!, beginning on page 210, for more on learning about color through hands-on painting experiences.)

73 OTHER COLOR SYSTEMS

The color wheels featured in this book (see page 15) were chosen because they are by far the most widely accepted visual models of color in use.

The only problem with these color wheels is that they are wrong. Well, not exactly wrong, per se, but not exactly right, either.

If you search online, you'll find there are several alternatives to the traditional color wheel—alternatives that are presented as circles, spheres, squares, cubes, spirals, and linear continuums. One of these alternatives to the traditional red-yellow-blue color wheel is particularly worth knowing about since, really, it's the one that provides artists with the most realistic model of color when it comes to using paints and inks.

This relatively unknown but worth-knowing-about color schematic presents itself in the familiar form

of a wheel, and its primary hues are cyan, magenta, and yellow (versus the red, yellow, and blue of the traditional color wheel). With cyan, magenta, and yellow as its primary hues, the CMY color wheel

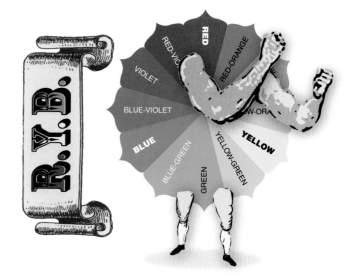

features green, red, and blue as secondary colors. More than a few painters and designers feel that this particular wheel of color is really the one we all should be using.

What makes the CMY color wheel possibly superior to the RYB (red-yellow-blue) model that most of us are familiar with? For one thing—as many painters and designers have discovered—within the real world of

paints and pigments, the CMY color wheel simply offers more options. For example, there's really no way to produce a true cyan or a true magenta using the traditional primary pigments of red, yellow, and blue. Try it and you'll see. On the other hand, the CMY color system has cyan and magenta at its core, and is fully capable of producing all the colors of the red-yellow-blue wheel, along with just about any other color you can imagine. Many painters also find it's easier to create certain warm and cool shades of gray using cyan, magenta, and yellow as primary colors than it is through mixtures of red, yellow, and blue.

Another nifty thing about the CMY color model is that it connects beautifully with the CMYK inks used in process-color printing. This means that designers who are adept at using the CMY color wheel tend to be very capable of envisioning how CMYK inks can be formulated and adjusted for print jobs. (Interested in gaining experience with CMY colors? How about learning to paint with them? See page 214 for more.)

So, why are most of us taught the RYB color model in school instead of the more versatile and accurate CMY model? Who knows. Tradition, most likely. And also because the time-tested red-yellow-blue color wheel works just fine about 95 percent of the time.

Digital
Color

74 THE WYSIWYG DREAM

WYSIWYG—*what you see is what you get*—is an acronym/sentence often used in reference to an all-too-elusive dream held by designers and illustrators: the dream of knowing that the layouts and illustrations we create on our computer monitors will look the same (or very nearly the same) when viewed on other people's monitors and when printed.

WYSIWYG is a fantasy—for now, anyway—since monitors are manufactured and calibrated according to a variety of specifications and standards. And also because the challenges of finding perfect color matches between on-screen pixels and on-paper inks is a hurdle that those involved in the advancement of computer and print technologies have yet to overcome.

Still, one thing to know about this WYSIWYG dilemma is that it's not nearly as bad as it used to be. Standards regarding both on-screen colors

and printing inks are not only becoming more universally and consistently applied, they are also becoming ever more in sync with each other.

What can you do to help ensure—as best as possible, anyway—that WYSIWYG? Start by getting the best-quality monitor you can afford; using it in a room with consistent, chromatically balanced, and not overly bright light; calibrating it with the latest software; and, as an option, giving it regular checkups with a good-quality monitor-calibration tool.

Not sure which monitor, calibration software, or calibration tool to use? A thorough Web search should lead you to the latest news about each of these items. Ask for words of advice from other designers, too, and from printing professionals and photographers who have come up with good solutions for ensuring color accuracy.

Also, at least until the WYSIWYG dream becomes a reality, continue your practice of relying on accurate process-color and spot-color guides to help you choose colors for your print jobs, and always defer to the high-quality proofs provided by your printing company when making adjustments to the colors you apply to pieces that are destined for printing. (More on this kind of thing in the next chapter, Color and Printing, beginning on page 192.)

75 WEB-SAFE RGB

Here's the news, in case you haven't heard: The *Web-safe* palette is a thing of the past.

It's been quite a while since websites needed to be designed around a palette of 216 Web-safe colors—hues that could be presented on early-generation monitors as solid panels of color and without a smattering of tiny and annoying colored dots (an effect known as *dithering).*

The vast majority of present-day monitors can handle more than 216 colors without any dithering whatsoever. Millions more, in fact. So put aside your worries about unsightly dithering and apply whatever colors you like to your Web-posted designs and illustrations from now on.

Why do so many designers still choose colors from this outdated classification of hues when designing for the Web? It's hard to say. Maybe it's because there are still many computer programs that make the Web-safe palette just a convenient click or two away for designers who are looking for it. Or it could be because the relatively easy-to-remember hexadecimal codes for Web-safe colors are ingrained so deeply in the heads of some designers that they just keep right on typing them into their HTML and CSS documents out of habit. Then again, it could simply be because there are still many designers who haven't heard the good news—that the Web-safe palette is history.

76 LETTING THE COMPUTER HELP

By all means, let the computer help you choose colors and build palettes for the logo, layout, or illustration you're working on. After all, isn't that what computers are supposed to do? Make our work easier?

But first, as talked about on the opening spread of this chapter, make sure your monitor is calibrated as well as possible. Choosing and applying colors using a monitor that is not showing accurate representations of hues is like trying to play music on an untuned piano.

Here are a few thoughts and suggestions regarding color aids available through Adobe products.

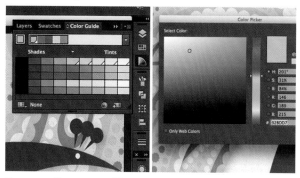

If you use Illustrator and haven't already learned about its Color Picker and Color Guide panels (both covered on pages 44–45), do so at once. Both of these tools will leave plenty of decision-making power in your hands while streamlining your path to efficient and effective color choices. (Photoshop offers an identical Color Picker panel but no Color Guide.)

Photoshop's Hue/Saturation, Black & White, Photo Filter, Solid Color, and Color Balance adjustment layers are must-know features that you can use in endless ways to flexibly alter, strengthen, and mute the colors in illustrations and photographs. (See pages 186–187 for more about adjustment layers.)

Adobe Photoshop, Illustrator, and InDesign allow users to save and import custom-made palettes (a palette being borrowed from another document, for example, or a palette downloaded from an online source). This can be a real time-saver if you work with similar or identical palettes across multiple documents, and also if you like to download color schemes from outside sources.* See your Adobe software's Help menu to find out exactly how to save, export, and import palettes using the .ase file extension.

The Swatch Library within Illustrator has a large selection of theme-based palettes that you can load into the Swatches panel for easy access.

Adobe products also connect with a neat little application called Kuler—an app that not only lets you create palettes from photos you shoot with your iPhone or iPad, but also lets you find and download palettes that others have created. Visit kuler.adobe.com for more info.

Additionally, as you probably already know, Illustrator, Photoshop, and InDesign each give designers complete access to spot-color catalogs (Pantone and Toyo, for example) through their Swatches panels. This is a nice convenience for designers who regularly work with print media.

*When letting the computer create palettes—or when downloading color schemes from outside sources—always remember that these palettes should not be thought of as absolute and final (unless you're bound to do so by something like a client's corporate standards manual). Make whatever changes are necessary to any or all of the palette's hues to produce a color scheme that meets the aesthetic and thematic goals of your eye and your project.

77 NOT LETTING THE COMPUTER HURT

If you ask a computer what 19999.8 x 5 equals, the computer will be able to tell you—in well under 1/100 of a second—the answer is 99,9999. The computer can also let you know exactly which CMYK formula is produced from a blend of two others. Computers naturally excel at answering questions like these because they can be both asked and answered in the computer's native dialect—the language of math.

But, is it the same to ask the computer what a particular blue-green is supposed to look like when it's muted heavily, or exactly what shade of yellow would look best as a complementary companion to violet? Nope. It's not the same. These are questions of aesthetics, and questions of aesthetics can be asked—and answered—only in the warm, fleshy, and fickle language of human preferences, opinions, and whims.

The computer, in other words, while perfectly capable of providing *answers* to questions involving numbers, is really entitled to offer only *suggestions* in response to color-related queries affected by matters of taste, fashion, fad, and theme. And to believe otherwise can hurt you.

Hurt? How? By making you lazy. And laziness is really the only word for it when we blindly accept mechanically derived *suggestions* as *answers* to questions involving aesthetics without giving our creative instincts and preferences a chance to weigh in on the matter.

So, by all means, let the computer be the authority when it comes to matters of math, but question that authority vigorously when it comes to aesthetics, and be willing to make alterations to—or to even reject— the so-called solutions that arise from software and circuitry.

COMPUTER

NO

DESIGNER

YES

DESIGNER

COMPUTER

78 DIGITAL BLENDING

Illustrator, Photoshop, and InDesign allow visual elements like panels of color, gradients, and images of visual texture (covered on page 134) to be added over the top of photos and illustrations. You can employ *blend mode* settings* to explore variations in how the upper panel of color or imagery affects the appearance of the colors in the underlying photo or illustration.

The results can be aesthetically and stylistically intriguing, and may be well worth investigating the next time you're looking for ways of finalizing the appearance of a photo or an illustration.

Don't be intimidated when you see how many blend mode options are offered through Adobe software. And don't worry if you find that you're unable to predict how each blend mode will affect the look of your photo or illustration. In fact, if you are new to blend modes, here's a suggestion: Just select a photo from your image cache and open it in Photoshop, add a Solid Color adjustment layer over the top, and then try out every option in the upper layer's Blend Mode pull-down menu and see how each affects the underlying photo (and try out different settings for the upper layer's opacity while you're at it). Exploring your options in this way will quickly build your sense for the ways in which you can use specific blend mode settings to achieve certain visual and stylistic outcomes.

*Blend mode settings—as demonstrated on the opposite page—establish the way in which the colors of one visual element interact with the colors of whatever sits beneath it. In Photoshop, blend modes are applied to layers; in Illustrator, blend modes can be applied to individual elements, groups of elements, and to layers; InDesign's blend modes can be applied to individual elements or groups of elements. See each program's Help menu for more about applying and altering blend modes.

186

Original image

Gradient Map adjustment layer

The same blue-to-yellow Gradient Map adjustment layer has been added over the top of the four identical photographs below. The different outcomes were achieved by selecting different settings from each adjustment layer's blend mode setting.

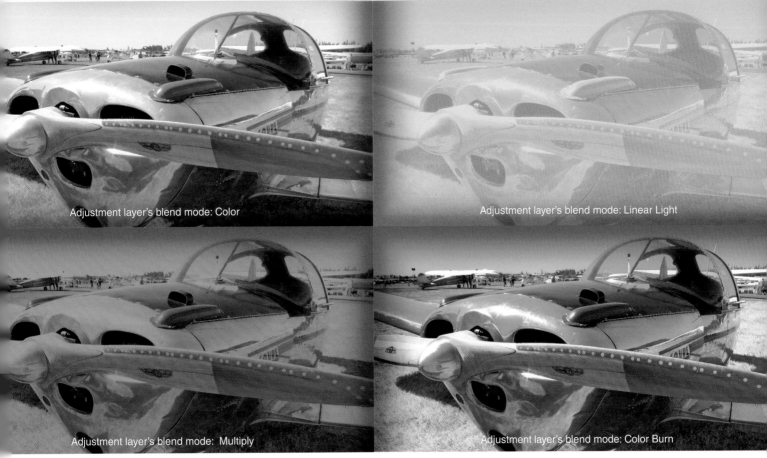

Adjustment layer's blend mode: Color

Adjustment layer's blend mode: Linear Light

Adjustment layer's blend mode: Multiply

Adjustment layer's blend mode: Color Burn

DIGITAL COLOR
79 INFINITE OPTIONS

Once you're satisfied with the look of the colors you've applied to your work of design or art, take a deep breath, congratulate yourself, save your document, and then open a fresh copy and get to work investigating some options.

And why not? What have you got to lose? After all, you already have one version that you feel good about, and the very worst that could happen by looking at further variations of your color scheme is that you just might come up with an even better idea.

It's been mentioned a few times in this book already, and it's important enough to bring up again here: The computer makes it incredibly easy to explore options in the way colors are applied to layouts, logos, and illustrations. So, explore!

188

80 REDEFINING POSSIBLE

The shape used as the basis for the herringbone pattern seen at right was created from scratch in Illustrator. The pattern was sent to Photoshop for use as backdrop material. Visual texture was added around the perimeter of the background pattern by adding a photo of a weathered piece of glass on top and using blend-mode settings and layer-masking tools to establish where and how the visual texture showed up. Images of a flower and a hoverfly were borrowed from separate photographs and placed over the herringbone pattern. Drop-shadows were added beneath the flower and the hoverfly, and the insect—along with nine of its clones—were arranged into a wedge-shaped flying formation. Typography was added in a way that suggests a dimensional interaction with the flower. A subtle spotlight effect was generated in the center of the piece using a Curves adjustment layer with portions of its layer mask painted in. A warm-colored Photo Filter adjustment layer was added to complete the look

of the composite image by helping its palette of varied colors visually gel. After that, the document was flattened, converted from RGB to CMYK, and placed into the print-ready InDesign document used to create this book.

All of this happened in just over 45 minutes, and during a coffee break.

Seriously. How is it that this has suddenly become possible, and even normal? That an image with this level of complexity can be produced and prepped for printing in about three-quarters of an hour with a cup of coffee in one hand and a mouse in the other?

The lesson? Keep in mind whenever you're brainstorming ideas for layouts and imagery, that— these days especially—notions of *possible* are in a continual state of flux. And take advantage.

| CHAPTER 12

Color and Printing

81 CMYK

What do you need to know in order to properly prepare your artwork for color printing? More than can be covered in this chapter, for sure, and it's recommended that you consult books, websites, printing professionals, and other designers to fully expand your knowledge of practical and technical aspects involved with printing in color.

This chapter covers several fundamental aspects related to color and printing—good foundational material upon which to begin building your knowledge of printing—starting with coverage of the four inks used to do most of the world's color printing.

CMYK* inks are used as the basis for both process-color printing (full-color printing done with offset printing presses) and digital printing (printing done using inkjet systems). Because of the economic factors involved, large-quantity print jobs are generally done using offset presses, and projects involving smaller quantities are increasingly being run on inkjet systems.

The way in which various CMYK colors are created on paper is by printing some or all of them on top of each other as either solid panels of ink or as over-lapping layers of various densities of tiny halftone dots (illustrated at right).

It's important to use a printed process-color guide as reference when preparing digital documents for CMYK printing: The colors you see on your monitor may or may not accurately represent how the colors will look when printed (see The WYSIWYG Dream, page 178).

Checking proofs and attending press checks (covered on pages 202–205) are critical in helping to ensure that any CMYK print job comes out well.

*The letters C,M,Y, and K stand for cyan, magenta, yellow, and black (K represents black since the black printing plate in process-color printing is sometimes called the *key* plate). These four colors of ink can be combined in various strengths to produce all the colors of CMYK printing.

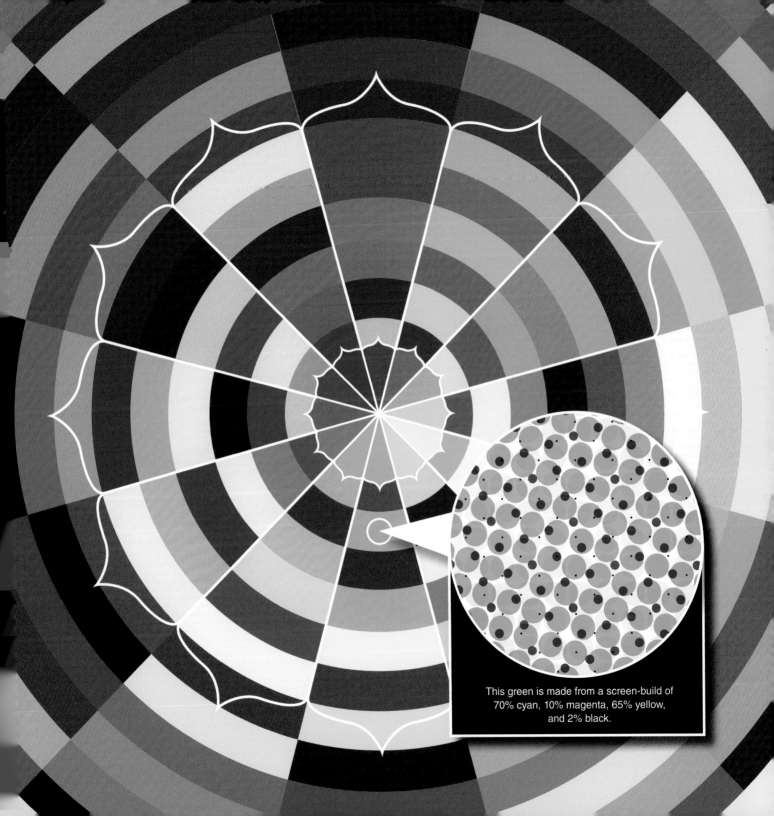

This green is made from a screen-build of
70% cyan, 10% magenta, 65% yellow,
and 2% black.

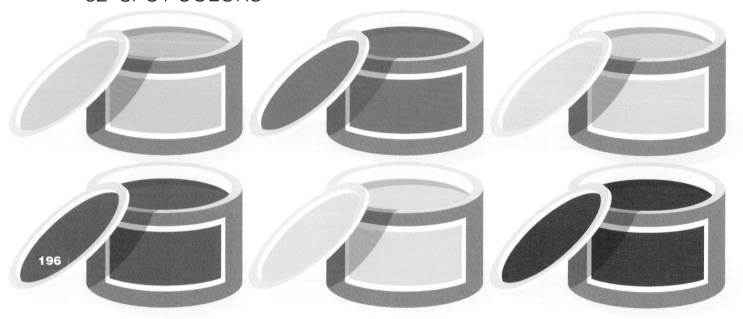

196

As mentioned on the previous spread, the endless variety of colors that can be created through process-color printing is the result of blends made from differing percentages of cyan, magenta, yellow, and black inks.

Spot colors, on the other hand, are inks that are formulated before they are even loaded into an offset printing press.* Spot colors are more like the ready-to-use, canned colors of paint you buy at the hardware store.

Spot color inks, like CMYK inks, can be printed as solids or as screens (halftone tints ranging from 1% to 99%). It's useful to remember this when designing artwork for print jobs that involve spot colors—that any spot color can be broken down into a monochromatic palette of different values.

The official color(s) of a company or an organization are usually chosen from a spot-color guide. This helps ensure consistency whether the color(s) are being used for stationery, promotional material,

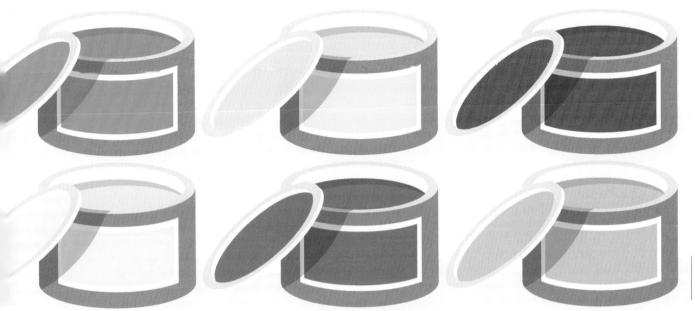

signage, or vehicle graphics. Pantone and Toyo are two companies that make extensive and popular catalogs of spot colors.

Why would a designer decide to use a spot color for an offset print job instead of producing the same color using a CMYK screen-build? There are two main reasons. The first involves economy, as in the case of a large-quantity print job that calls for black plus just one other color. Jobs like these are usually cheaper to run using two inks (black plus a spot color) than as a process-color job that calls for the four inks of CMYK printing. The second involves cases where large areas of paper are to be covered with a solid panel of a specific color: A solid application of spot-color ink will almost always be able to fill an area like this with a more consistent look of coverage, and with more visual richness, than could a CMYK screen-build.

*Spot colors can also be selected for digital printing, though the computer will convert these colors to CMYK formulas for the actual printing process.

83 INK VS. REALITY

Color theory is one thing. Color fact is another. Here are four thoughts about understanding and managing potential differences between the colors you expect from your printed pieces versus the colors you get.

Thought number 1. Wristwatches vary, toasters vary, cars vary, and so do machines that print. There's nothing we can do about this. When it comes to printing, many designers prefer to work with one or two companies for most of their print jobs. That way, they can get to know a thing or two about—and learn how to deal with—the tendencies and potential quirks of the machines being used.

Thought number 2. All the color theory in the world won't explain everything that happens when actual pigments are made into inks and used for printing: Chemical reactions between molecular components of certain pigments, impurities that find their way into batches of ink, and inconsistencies in the ways different human beings handle printing machines ensure that nothing can really be taken for granted

when working with colored inks. Just be aware of this and try to be somewhat flexible and understanding when you patiently work with your friendly neighborhood printing professional on your next color print job.

Thought number 3. CMYK printing inks, and most spot colors, are semitransparent. This means that the color of the paper you are using for a job will likely affect the color of any inks that are printed on it (more on this on the next spread).

Thought number 4. The machines that do our offset printing are subject to minor (and sometimes major) shifts in the way they are able to apply ink to paper during the course of a print run. A good press operator is one who can get a job looking good at the beginning of a run and keep it looking good until the last piece comes off the press. Find press operators like this and stick with them—even if it means explaining to your client why sometimes they need to go with someone other than the lowest bidder for a print job.

84 THE PAPER EFFECT

CMYK inks are semitransparent. This means the color of the paper you're printing on—if it's anything other than white—will have an effect on the look of your printed colors. Most of the time this is not a major issue for designers, since papers that are white or nearly white are the most common choices for print jobs.

adjustments to your document's colors so that they will print like you want them to print. If, for example, you're using a paper that's a medium-light shade of golden-yellow, and if your design includes photos of people whose skin tone you want to preserve, then you might decide to shift some or all of the colors in your photos slightly away from the yellow spectrum, since the paper will provide hints of this color on its own.

It's never an easy thing to accurately predict the outcome when CMYK or spot colors are laid down on

If you decide to go with a paper that has a notable amount of color to it, then—depending on the final result you're after—you might need to make

Keep in mind, too, that a paper's finish will affect the look of printed inks. Most papers fall into the category of being either coated or uncoated. A coated stock has a hard finish that is usually glossy, and uncoated stocks usually have a slightly felt-like feel and a matte

colored paper, so be sure to ask your print or paper representative for advice about preparing your print-ready document.

One thing you can conveniently do to get a general idea of what your job will look like when printed on a nonwhite stock is to print part or all of it on a sheet of your chosen paper using a good-quality inkjet printer. You can't rely on this sort of test for 100 percent accuracy, since you'll probably be running it on an inkjet printer that handles color differently than the digital printer or offset press that will be used for the actual job, but it will help give you an idea of what to expect.

201

finish. Coated stocks present colors with maximum crispness and saturation, since they don't absorb ink as deeply into their fibers as uncoated stocks.

85 AVOIDING DIFFICULTIES

There are several things you can do to make things go as smoothly as possible when preparing files for color printing—starting with taking very seriously your job of making sure quality-control checks have been made of every aspect of your layout's text, images, logo, decor, and colors before sending it out for printing. The only thing more stressful—and more cost-inducing—than making last-minute changes to a document's artwork prior to printing is having to reprint a job because errors weren't caught in time.

Make sure the images in your for-print documents have been set up at 300dpi—the standard resolution for nearly all printed material (on-screen images, on the other hand, are generally prepared at 72dpi).

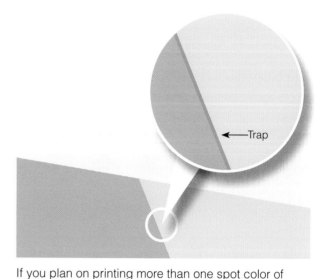

←—Trap

If you plan on printing more than one spot color of ink on an offset press (black being considered a spot color, too, in this case), and if your colors are to touch each other, then be sure you know how to set up the trapping between your colors properly. Trapping is a technique of document preparation that allows different colors of ink to overlap very slightly so that no tiny white gaps appear between them when (not *if,* but *when*) the printing press's ability to align them with exact precision falls even slightly out of true. Illustrator and InDesign both offer tools that handle trap settings. Look into these tools, and also consider getting help from an experienced designer or a printing professional when figuring out the best way to implement the trapping for a print job. (It's worth knowing, too, that many printing companies will offer to do your job's trapping for you—for a cost, of course—if you'd prefer.)

Don't attempt to print fine type or linework using screens or screen-builds: There simply might not be enough room within the thin letters or lines to hold the halftone dots necessary to make them show up properly.

Avoid reversing fine type or linework from screen-builds that include more than two colors of ink: It may be extremely challenging for the printer to maintain registration that's accurate enough to keep the reversed letters or lines from filling in with halftone dots. Also—for the very same reasons—avoid reversing fine type or text from areas of rich black (black that is made from more than one color of ink, as described on page 90).

86 PROOFING AND PREDICTING

Your printing company should provide you with a high-quality prepress proof prior to running your job on either an offset press or a digital printer. The purpose of this proof is to allow you to confirm that everything looks as it should.

If you've been careful to use just the right CMYK formulas for the colors in your document and have properly prepared your artwork for printing, then the proof should confirm that your job is ready to print. If something is amiss, then—depending on who is responsible—either you or the printer will need to make fixes, and another proof will need to be generated and reviewed.

In the event that everything looks good, you'll be asked to sign the proof as evidence that the job is approved for printing. Consider asking someone who has been authorized by your client to sign off on the prepress proof as well. This additional signature can help ensure that you won't be held liable if something has been missed during this— or any previous—stage of the job's development and review.

With a signed proof in hand, the person responsible for running your job will then be charged with ensuring that the printed pieces and the prepress proof match each other as closely as possible.

There are a couple of important things to know about prepress proofs. First of all, they are usually printed on white paper. If your offset printing job is to be printed on anything other than a white stock, then—as talked about on pages 200-201—you'll have to make allowances for the effect the paper's color will have on the look of the inks being printed on it.

Also, if your job is being run on an offset press,
know upfront that the pieces coming off the press will
probably never be an exact color-match with the proof
you reviewed and signed. This is simply because the
proof was almost certainly generated digitally, and
it's next to impossible to coax a digital printer and
an offset printing press to fully agree on color output,
since they use different kinds of ink.

If, on the other hand, your print job is being handled
digitally—as more and more print jobs are—then
chances are good that the proof you review will
have been generated by the same machine that
will be performing the print run. In cases like this,
you're safe in thinking of the prepress proof as
an accurate representation of how the final
product will look.

87 PRESS CHECKS

Finally, once you have reviewed, approved, and signed the prepress proof, your color print job is ready to go to press. What's left for the designer to do? Attend the press check, that's what.

A press check is where you're given the opportunity to inspect your job in real time as it's being printed.

At a press check, you, the designer, will be shown samples of your printed piece. You'll compare these samples with the prepress proof that you signed off on. If the colors of the printed piece don't match those on the proof, or if any other oddities or errors are showing up on the printed sheet, then you'll work with the person running your job to make things right.

As mentioned on the previous spread, if your print job is being run on an offset press, it's very likely that the colors of your printed samples won't precisely match those on the prepress proof. Your role, in cases like this, becomes that of adjudicator and decision maker as you make whatever judgment calls (and compromises) are necessary to ensure that the printed piece's colors look as good as possible—regardless of whether or not they perfectly match those on the proof.

Also, when working with a press operator on a job that's being printed on an offset press, be sure to listen carefully to what that person is telling you about which kinds of adjustments are possible, which will be challenging (but doable), and which are out of the question. Offset printing presses are incredibly complicated, and it takes time and expertise to coax all the knobs and levers of these mechanical wonders to do what's needed to produce perfectly printed pieces. So be patient and diplomatic while a press operator is working hard to get things dialed in—and continually remind yourself that every press check is an opportunity to either build or destroy a good working relationship with the professionals who are responsible for the look of your printed works of design and art.

Top ten things to do at a press check:

☑ Arrive on time ☑ Work with the press operator to ensure the piece's colors match the proof as closely as possible ☑ Check for consistent ink coverage throughout ☑ Make sure all images look good ☑ Carefully inspect the entire piece for unwanted blemishes ☑ Confirm that the correct paper is being used ☑ Double-check that the right number of pieces are being printed ☑ Make sure the piece will fold properly (if applicable) ☑ Work courteously, patiently, and professionally with your press operator and print rep at all times ☑ Sign off on a printed sample once you're satisfied with the look of the piece (and hang on to a signed copy for your files as well).

88 EXPERIENCE: THE TEACHER

It takes time to learn how to create color documents that can be reliably printed in ways that meet—and exceed—the expectations of our clients and ourselves.

As most longtime designers can tell you, perfection can be an elusive goal when it comes to the media of ink-on-paper, and the path to proficiency can be filled with more than its share of errors, miscalculations, unpleasant surprises, and unforeseen complications.

What you need to get there is a good instructor, and there's no better teacher of the ways of printing than experience itself. So start your apprenticeship as soon as possible, and simultaneously augment your learning through books, websites, classes, software guides, and other designers. Regularly ask the printing professionals you work with for advice, too, whenever you come across areas of concern when preparing color documents for printing. And when

you do send a job to a printing company for output, take part in (or at least keep an eye on) as many stages of the printing process as possible—from document prep to proofing, revision-making, press checks, and bindery (cutting, folding, stapling, and so on).

If things do go poorly with a print job, be sure to figure out exactly what went wrong and exactly how things could have been done differently in order to prevent the problems from occurring in the first place. Mistakes are every bit as important as successes when it comes to perfecting our abilities to create print-ready documents, and to deal smoothly and effectively with the professionals who do our printing for us.

Inspect printer's proof

Look good?

YES

NO

Fix it

Let the printing begin

Attend press check (see previous page)

DOES FINAL PRODUCT LOOK GREAT?

YES

NO

Congratulate yourself and assess what went right

Figure out exactly what could have been done differently to make the job run perfectly

Save this knowledge for the...

next time...

Paint?
Paint!

89 PAINT, AND KNOW

Painting is a great way to learn about color, especially for the many of us who learn best—and remember the most—when our eyes and our hands are involved in the learning process.

Before expanding on the notion of hands-on painting in the pages ahead, here are a few thoughts about some differences between digital and analog media.

Now, it's one thing to have a blank Photoshop document open on your computer, with the Brush tool selected and the Swatches panel ready to go, and it's clearly another thing to have a blank sheet of art paper, a jar of water, three or four paintbrushes (tipped with either synthetic or natural fibers), and a watercolor tray dabbed with small beads of wet pigments sitting in front of you on a work table… ready to go.

Digital and analog mediums are both perfectly capable of enabling the creation of beautiful art. And digital tools do have certain advantages over analog media: the Undo command, for instance. It's also a lot easier to clean up after working digitally than it is after an art session involving watercolors, acrylics, or oils. But does that make digital media the best choice for learning about painting and color?

No. Not in the minds of many design and art professionals who have experienced—and enjoy—both digital and analog creative media. And here's why. When it comes to the fundamentals of painting and color, it's very important to recognize that digital is a copy: Digital paints and paintbrushes are the imitation, and paint and paintbrushes are the imitated.

So why not deal with the real thing first, and then (if you feel so inclined) apply what you learn to digital media? That way—having experienced true-to-life interactions between different kinds of papers, paints, and brushes—you'll be able to judge whether or not your digital media is pulling off a respectable imitation of the media it's trying to represent. And with this knowledge you'll be able to decide whether

you want to go along with what the computer is doing, or if you're going to need to look for ways of bending its will toward your own.

90 KINDS OF PAINT

Watercolors (most likely in the form of small rectangular cakes of pigment stored in flat metal tins) were the first painterly medium that many of us experienced. The irony here is that watercolors—while extremely easy to use—are considered by many artists to be particularly difficult to master. What is it that can make this form of paint so challenging to deal with? Simply that watercolors are a transparent medium, and therefore it can be next to impossible to gracefully cover or correct mistakes with the addition of more watercolors.

This isn't to say that you shouldn't learn to paint using watercolors, but rather, that you should possibly consider other options as well.

How about acrylics? Acrylic paints are conveniently water soluble when they first come from the tube, and are waterproof once dry. This means you can add a layer of acrylics to paper or canvas, allow the paint to dry, and then cover it with additional layers of acrylics without worrying about smudging or dissolving the pigments below. You can apply acrylics as semi and fully opaque pigments, and you can thin them to behave like watercolors.

Oil paints are worth considering, too. Oils have been around for a long, long time and they're still going strong. The main differences between working with oil paints and using acrylics is that oils take longer to dry, and also that you'll need to use products like mineral spirits, turpentine, or organic-based solvents instead of water to thin your paints and to clean your brushes. If a well-ventilated, dedicated art space is available to you, and if you like the idea of working with paints that take their time drying, then oils might be something you'd enjoy using.

Several manufacturers of acrylic paints make tubes of cyan, magenta, yellow, and black that are very similar in color to the CMYK inks used for printing. How about using tubes of these paints—along with some white—to begin your paint-based explorations of color? This will likely increase the chances that the lessons you learn while painting will have a good chance of proving relevant and useful when you're working with CMYK ink formulas for future design and illustration projects.

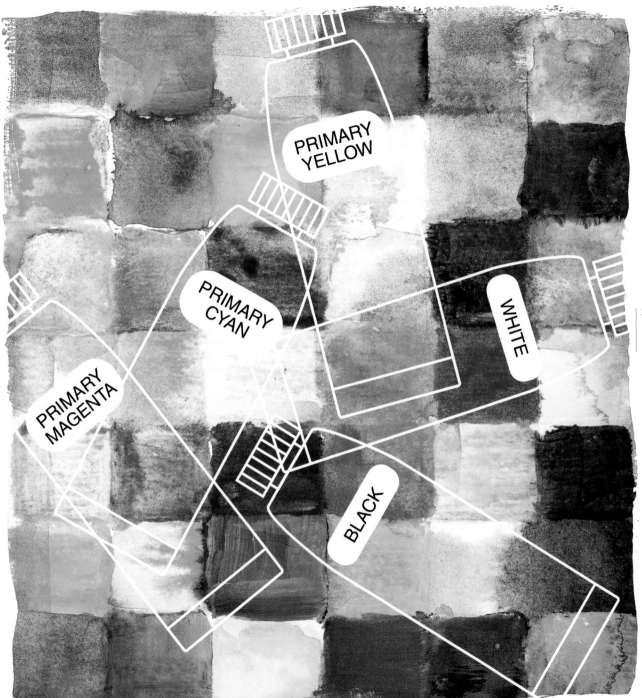

PRIMARY YELLOW

PRIMARY CYAN

WHITE

PRIMARY MAGENTA

BLACK

215

91 BRUSHES AND PAPER

Art brushes are usually made from synthetic fibers (nylon, most often) or fur from sables, badgers, oxen, goats, squirrels, or camels. There are many different styles of brush—the four most common being rounds, fans, flats, and filberts. Rounds are what most painters employ for detail work, and these come in numerically designated sizes ranging from an ultra-fine 0000 to a thick-bodied #14 and above.

If you're just starting out with painting and are looking for brushes, keep things simple and affordable. A fine-tipped nylon round (probably a 0 or a 00) along with a thicker #4 will give you plenty of versatility and control when it comes to applying paint to paper.

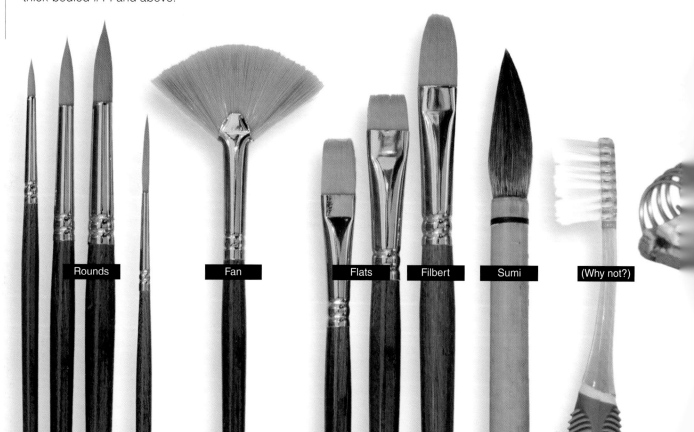

Rounds Fan Flats Filbert Sumi (Why not?)

If you're thinking about using a set of cyan, magenta, yellow, black, and white acrylics like those mentioned on the previous spread—or any other set of water-soluble paints—pick up a pad or a block of sturdy watercolor paper to work on.

Blocks of watercolor paper are especially handy since they are bound on all four sides. This keeps the paper from curling when it gets wet and also helps the sheet dry perfectly flat. Once your painting is dry you can remove it from your watercolor block by cutting it free with the tip of a table knife.

Pad

Block

92 PROJECT IDEAS

What to do with your paper, paints, and brushes? Have a good time, first of all. The work we do as creative professionals is more than capable of adding sufficient amounts of stress to our lives, so make a point—from the beginning onward—to keep your hands-on exploration of painting and color as pleasurable as it is enlightening. Besides, we tend to

stick with activities longer, and therefore learn more from them, if they are enjoyable: So keep painting fun.

Goof around. Just gather your art supplies and get to work… or rather, to play. Brush, smear, dab, scrub, and flick paint onto paper. Mix your straight-from-the-tube colors into a wide variety of hues with an assortment of values and levels of saturation. Try out different amounts of water (or paint thinner, in the case of oils) in your mixtures of paint, and, if you're working with acrylics, also consider investigating the effects of using a matte or a gloss medium (a thick, white, glue-like substance that dries clear) to thin your paints. Be abstract, be experimental, be inquisitive, and be bold: This is your chance to begin establishing your feel for how paper, paints, brushes, and mediums can associate to create both colors and art.

Go abstract. Jump right in and paint a shape, line, squiggle, or splotch on your piece of art paper. And then let your creative instincts tell you what to do next, and what to do after that, all the way to the finish of a spontaneously conceived expression of nonrepresentational art. And be sure to learn a thing or two about color as you work: How about building your piece's color scheme around one of the palettes described in Chapter 3?

Experience values. Use your computer to create a simple pattern that includes three or four values of gray ranging from 10% to 80%. Print the pattern onto an ordinary piece of paper and glue the sheet to a sturdy piece of cardboard with matte acrylic medium. Next, add another coat of the medium over the top of the printout (this will give you a nice waterproof surface to work on for the steps ahead).

After everything has dried (use a blow-dryer to speed things along, if you like), you'll be painting over the top of the pattern with a variety of colors whose values match the grays they cover. Mix up a color you want to use—in a value that seems close to what you're aiming for—and then place a small dab of the paint on top of the gray you're trying to match. Squint your eyes to help them see whether the color is the right value or if it needs to be made darker or lighter. This will take some patience and effort to get just right, but it's time and effort well spent since you will be learning about color, value, and the nature of paints with every correction or adjustment you make to the color you're mixing. Once you're happy with the value of your paint mixture—as well as its hue and its saturation—use it to fill its assigned segment of the pattern. Continue this until the entire pattern is covered with color. Be willing to go back and make adjustments to earlier colors if one of your hues suddenly appears too dark, light, muted, or bright in comparison with nearby hues. Keep at it until you're fully satisfied with your painterly pattern.

Learn to mix. Create a color wheel with paints. Simple as that. Sound too structured and scholastic? Then find a way to spice things up. Maybe fill your color wheel's spokes with monochromatic decor, devise an intriguing backdrop for your wheel, or come up with your own depiction of exactly what a custom-painted and fully expressive wheel of color ought to look like.

93 GOING FURTHER

Nearly all designers and illustrators can benefit from an ongoing practice of working with paints and colors—fairly regularly, just for fun, and for the purposes of both enjoyment and learning. A habit like this helps perpetuate our awareness of the inner-workings of color while enforcing synaptic connections between our hands and eyes that serve us well as visual artists—whether or not the words *illustrator* or *fine artist* ever appear on our business cards.

One thing that can really help establish a skill-and awareness–enhancing creative habit like this is to keep our art supplies stored in a place that's visible and convenient: Keeping art supplies visible helps us remember to use them, and keeping them convenient eliminates a host of excuses that might otherwise interfere with all kinds of spontaneously conceived creative projects.

What to do with your art supplies—with or without advance planning? For one thing, each of the projects mentioned on the previous page could be taken in an infinite number of directions and to endless degrees of complexity. Also, you could grab a favorite coffee cup, vase, toy, or salt shaker and paint its likeness. Seriously: Still-life paintings like these can be as fun, educational, and rewarding as you dare to make them—try it and see. And what about painting a portrait? Choose a photo of a friend from your image cache and paint a representation of the image using exactly the skills you have right now. Here's one more idea: the art party. This is where you invite one or more friend over, put on some good music, and have them join you in creating art—just for fun, laughs, and learning.

Surely, any of these ideas—plus any of the countless others your brain is capable of generating on its own—would be a more than worthwhile substitution for an evening or a weekend afternoon spent watching pointless television or aimlessly surfing the Web, would they not?

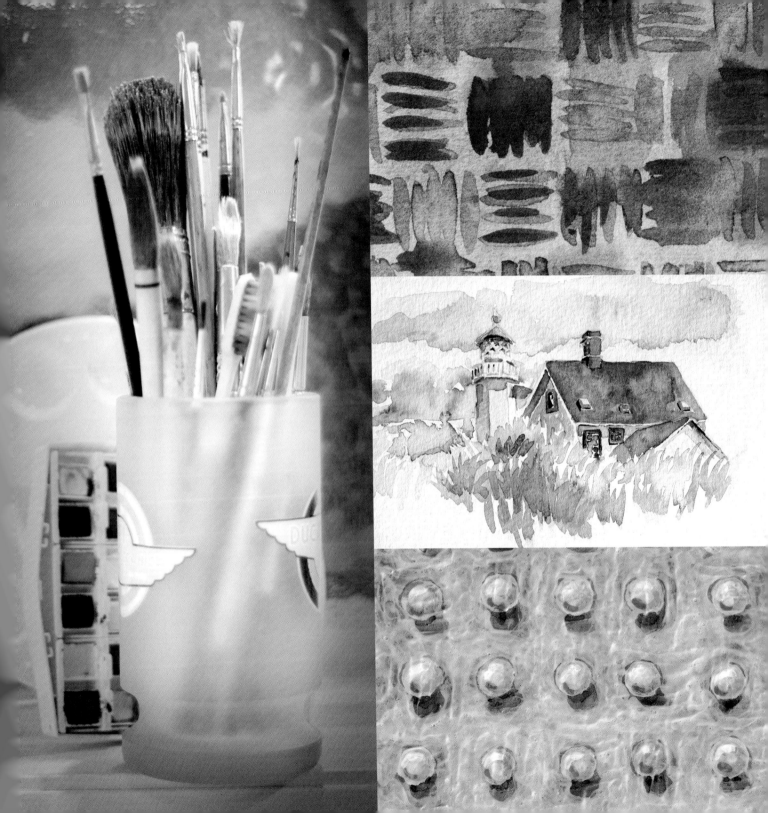

94 THE DRAWING CONNECTION

222

Here's a spread—right before the conclusion of *Color for Designers*—that has no direct connection with color. How could this happen? And why? It's because no talk of painting could be complete without mention of drawing.

The ability to draw, even in its most interpretive and basic form—that of loosely capturing the visual gist of a person, place, or thing through simple strokes made with a pencil or pen—is never wasted on the visual artist. This is true whether the artist is involved in design, illustration, fine art, photography, cinematography, crafting, interior design, fashion design, or architecture. Drawing, after all, is not only its own form of creative expression and communication, it's also a means of developing and advancing other forms of expression—ones like those mentioned above.

And that's why drawing comes up here, in a chapter about painting: because if you really want to pursue

painting, pursue drawing, too. If nothing else, a reasonable set of drawing skills will at least help you speed through the initial stages of an illustration or a work of fine art and get you to what many people consider to be the really fun part of a painting project—the stage where colors, brushes, and paper are finally allowed to meet.

Learn to draw by doodling and making sketches while waiting for other things to happen (a bus to arrive, a movie to begin, a dentist to see you, and so on), taking a weekend or an evening drawing class, attending noninstructed figure drawing sessions, encouraging your eyes to see negative shapes*, and, occasionally, by sitting down with a pencil and a piece of paper and telling yourself it's time to sit, stay, and practice.

*A few such shapes have been highlighted above. Seeing and drawing negative shapes is a good way to trick your brain into drawing things as they really look—rather than according to how you might have *thought* they looked.

95 TECHNOLOGY AND DESIGN

To wrap things up, a few words about technology within the realm of art.

A few decades ago it would have been almost unthinkable to believe, for instance, that painters would one day be able to practice their art using software in place of paints, monitors in place of paper, and nonwriting pens pressed against plastic tablets in place of brushes.

What happened to so quickly reduce—and even eliminate—gaps between what we can do using digital media and hands-on art tools? A whole lot of software and hardware engineers put in a great many late nights at the office. That's what. And not only did these talented and hard-working individuals write some amazing code, and develop some incredible input and output devices, they also consulted closely with bona fide real-world art professionals to come up with products that can be used to produce works of design and art that both mimic and move beyond those that can be created using traditional media.

What does this mean to those of us who design, illustrate, take pictures, make videos, or create works of fine art for a living? Among other things, it means we need to: pay attention to the technologies that affect our creative practices; be willing to adapt to tools and software that allow us to work better and faster; and never forget that truly creative people can always find ways of conveying information, ideas, and emotions through visual media using art tools of just about any era—past or present.

So, pay attention, first of all. Open your eyes, ears, and mind to what's happening in technologies that affect creativity. Make regular visits to three or four websites, and/or subscribe to a magazine or two, that highlight advancements in areas that are relevant to your creative interests. Let

these sources do the work of funneling and curating ever-surging masses of late-breaking information into manageable and easily understood parcels of relevant particulars that you can assess on your own.

When you do come across a new piece of software or hardware that looks like it'll be able to help you create your outstanding works of design and art more efficiently, and/or allow you to pursue appealing new avenues of creativity—and if that product is something that's within your means to acquire—then think seriously about getting it and learning how to use it. In the past, art professionals could enter their career using a particular set of tools, and then spend their entire career perfecting their skills with the very same media. Things are different these days. Very different.

Also, with shiny new technologies continuously appearing before our eyes, we have to be careful not to fall into the trap of thinking things like, *If only I had this video camera, I could create that short film I've always wanted to make*, or, *If only I had that stylus screen, I could do the kinds of illustrations that would land me the really juicy contracts.* It's true, certain products can help us do the kind of work we've always dreamed of doing. But until we have those products at our fingertips, we have no other choice than to use what we have and to make the most of it. Which isn't a bad thing, since limited resources encourage—and often demand—just the kind of expansive creative thinking that can lead to true creative genius.

Glossary

GLOSSARY

Note: The definitions provided here are given within the sense of how these terms are used within the content of this book.

Additive color

Systems of color involving light. The primaries of additive color are red, green, and blue (RGB, for short). Full amounts of all three primary colors of light produce white, and the absence of all three equals black. Secondary colors of the additive color wheel are yellow, magenta, and cyan.

Analogous palette

Sets of three to five hues that come from adjacent spokes of the color wheel. Further described and illustrated on page 50.

Annual

A publication centered around topics related to design and art that's issued once per year. Annuals usually feature the work of influential and trendsetting creative professionals.

CMY

An acronym for *cyan, magenta,* and *yellow*—the hues of a color wheel that features these colors as its primaries. Many painters favor the CMY color wheel since it connects more closely to the behavior of actual pigments than does the traditional red-yellow-blue color wheel.

CMYK

An acronym for *cyan, magenta, yellow,* and *black* (the letter K is used to represent black since the black plate in offset printing is sometimes referred to as the *key* plate)—the four inks used for process printing.

Color

Technically speaking, colors visible to the human eye are oscillations of electromagnetic energy with wavelengths measuring from about 400 to 700 nanometers. White light is a mixture of all colors. Black is the absence of light.

Color Guide

A panel offered through Illustrator that features dark, light, muted, and brightened versions of specific colors.

Color Picker

A panel offered through Illustrator and Photoshop that can be useful in finding dark, light, muted, and brightened versions of specific hues.

Color wheel

A two-dimensional schematic that presents primary, secondary, and tertiary hues. Color wheels are useful aids when visualizing relationships between hues and when looking for ways of assembling different colors into palettes.

Complementary colors

Hues that sit directly across from each other on the color wheel.

Cool gray

A gray with hints of blue, violet, or green. Also see *Warm gray.*

Cool hue

Colors that tend toward blue, violet, or green. Also see *Warm hue.*

Digital printing

Printing that is done using inkjet printers.

DPI

Acronym for *dots per inch,* a measurement used to define the resolution of digital images. More dots per inch generally equate to sharper-looking images.

Eyedropper tool

A tool offered through Illustrator, Photoshop, and InDesign that allows users to select specific colors from photos, illustrations, and graphics—and (if desired) apply them elsewhere.

Halftone dots

Tiny dots of varied size that appear within printed images. Halftone dots are usually too small to be seen without magnification and, when viewed by the unaided eye, result in gradients of value that give form to the content of images and illustrations.

Hue

Another word for color.

GLOSSARY

Illustrator

An Adobe program that specializes in the handling of vector-based graphics.

InDesign

An Adobe program primarily used to created layouts for both print and the Web.

Inkjet printer

A digital printer that puts colors onto paper through the application of microscopically small dots of ink.

Monochromatic palette

A set of lighter and darker versions of a single hue. The eye has trouble telling the difference between more than seven or eight members of a monochromatic palette, so it's rarely necessary to include more than that. Further described and illustrated on page 48.

Mute

To lessen the saturation of a color. Cool hues tend toward cool grays when muted; warm colors tend toward either warm grays or browns when muted.

Neutrals

Grays and browns.

Offset printing

Printing done with traditional printing presses that apply ink to paper using a series of rollers.

PMS

Acronym for Pantone Matching System—a large collection of spot colors offered through Pantone.

Palette

A specific color scheme applied to a layout or an image.

Photoshop

An Adobe program designed to enhance and modify pixel-based digital images. Many art professionals also use Photoshop to create illustrations.

Primary colors

The foundational hues of a color wheel—hues that cannot be created using any of the other colors of a wheel. The primary hues of the traditional color wheel (used throughout this book) are red, yellow, and blue.

Prepress proof

A proof provided by a printing company prior to running a print job. Most prepress proofs are output digitally.

Press check

The opportunity for a designer and/or client to inspect a printed piece as it is being run. Press checks provide the final opportunity to manage the quality of a printed piece.

Process color guide

A book of large numbers of printed swatches of various CMYK colors. Designers refer to these swatches when choosing colors for print jobs since on-screen representations of color can be misleading.

Process color printing

Printing done on an offset press using CMYK inks. (Also called *process printing*.)

RGB

An acronym for *red, green,* and *blue*—the primary hues of the light-based spectrum of color.

Reverse

To allow an element of a printed piece (type, linework, decorations, and the like) to appear as the paper color within areas of ink coverage. White type, for example, has been reversed when it appears within an area of black or colored ink.

Rich black

Black that's been printed using more than just black ink. Rich black delivers a visual richness not seen when black ink is used alone. Four different CMYK formulas for rich blacks are featured on page 91.

Saturation

The intensity of a hue. A fully saturated hue is a color in its most intense and pure state. Muted versions of hues have lesser levels of saturation.

Screen

A halftone pattern that ranges in density from 1% to 99%. You can lighten inks by printing them as screens.

GLOSSARY

Screen-build

When two, three, or all four of the CMYK colors of process printing are applied on top of each other—each as a specific screen density—to produce specific colors.

Secondary colors

Hues made from blends of primary colors. The secondary hues of the traditional color wheel (used throughout this book) are orange, green, and violet.

Split complementary palette

A set of colors taken from one spoke of the color wheel along with the two spokes on either side of that color's complement (best described visually, as seen on page 56).

Spot color

Ink colors that are premixed prior to being added to an offset printing press. Designers usually select spot colors from printed or on-screen guides offered by companies such as Pantone.

Spot-color guide

A printed swatch-book of various spot-color samples. Pantone and Toyo are two companies that produce popular and commonly used spot-color guides.

Subtractive color

Systems of color involving pigments. The primaries of traditional subtractive color systems are red, yellow, and blue. The color wheels shown on page 15 each obey the principles of subtractive color.

Target audience

The specific demographic being aimed for with a commercially purposed work of design or art.

Tertiary colors

Hues made from blends of primary and secondary colors. The tertiary hues of the traditional color wheel (used throughout this book) are red-orange, yellow-orange, yellow-green, blue-green, blue-violet, and red-violet.

Tetradic palette

Sets of hues taken from four spokes of the color wheel—spokes that associate with each other by way of either a square or a rectangular configuration (best described visually, as seen on page 58).

Triadic palette

Sets of hues taken from three equally spaced spokes of the color wheel. Further described and illustrated on page 52.

Value

The darkness or lightness of a color on a scale that goes from near white to near black.

Visual hierarchy

The apparent visual priority of a composition's elements. A strong sense of hierarchy occurs when one element of a composition (a layout's headline or a photograph's main subject, for example) clearly stands out above the piece's other visual components.

Visual texture

A freeform or geometric repetition of abstract or representational shapes (best defined through actual examples, as seen on page 57).

Warm gray

A gray with hints of brown, yellow, orange, or red. Also see *Cool gray.*

Warm hue

Colors that tend toward yellow, orange, or red. Also see *Cool hue.*

WYSIWYG

Acronym for *what you see is what you get.* WYSIWYG is often mentioned in regard to the elusive goal of matching on-screen hues with printed colors.

234

Index

INDEX

INDEX

INDEX